CHINESE PAINTINGS
FROM THE SHANGHAI MUSEUM
1851-1911

NMS Publishing

ACKNOWLEDGEMENTS

We would like to express our deep gratitude to the Shanghai Museum for giving us the opportunity to show its marvellous collection of Chinese paintings for the first time in Britain. Particular thanks are due to Mr Chen Xiejun, Executive Director; Professor Wang Qingzheng, Vice-Director; Mr Shan Guolin, Chief of Department of Calligraphy and Painting; and to the museum staff for making this exhibition available to Scotland.

This exhibition is a significant contribution to the cultural exchange programme between the People's Republic of China and Scotland. We are very grateful to the Cultural Office of the Embassy of the People's Republic of China in London for their support and assistance.

Tremendous support has been received from Lord Wilson of Tillyorn GCMG and Sir William Purves CBE DSO, to whom we owe a debt of gratitude.

Special thanks are due to Professor Roderick Whitfield who, in addition to contributing the preface, has offered us his professional expertise and valuable guidance; to Ms Susan Y Y Lam for the English translation and for her assistance in obtaining research materials from Hong Kong. Thanks are also due to Professor Ju-hsi Chou, Professor Craig Clunas and Dr Zhang Hongxing for their assistance.

Finally, thanks and warmest appreciation to everyone at the National Museums of Scotland who has helped in the production of this book.

Illustrations: 27, 28, 30, 34: Hai Feng Publishing Co

Cover
Detail from Birds by Ren Yi in the Album of Various Subjects (1886)

STANDARD LIFE

Standard Life is delighted to have the opportunity to support *Chinese Paintings from the Shanghai Museum*; Shanghai is a city with which the company has enjoyed a long association. Standard Life insurance policies were sold in the city from the establishment of its first agency in Shanghai in 1846 until the company's Far East office on the Bund was closed in 1937. Standard Life's interest in China continues to this day and in 1996 the company opened its first office in the new China, in Shanghai.

Published by NMS Publishing Limited, Chambers Street, Edinburgh EH1 1JF
© NMS Publishing Limited and the authors 2000

British Library Cataloguing in Publication Data
A catalogue record of this book is available from the British Library

ISBN 1 901663 48 5

Designed by NMS Publishing Limited
Printed in the United Kingdom by Clifford Press Ltd, Coventry

CONTENTS

Acknowledgements 2

Foreword 5

Preface 7

The Cultural Significance of the Shanghai School *Shan Guolin* 9

Reinterpreting the Shanghai School of Painting *Anita Chung* 25

Notes 45

Artists and their Works *Anita Chung* 47

Further Reading 127

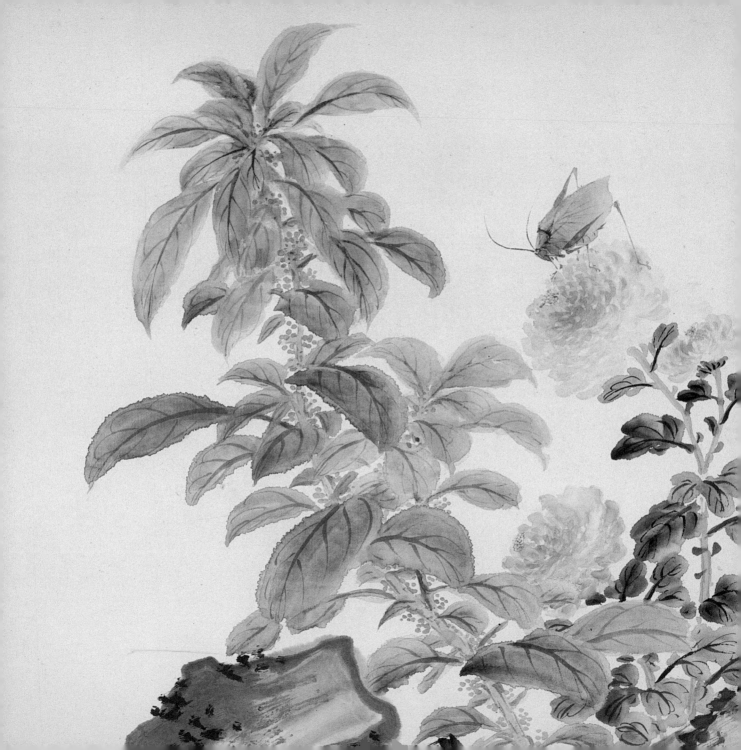

Foreword

From the 1840s onwards Shanghai developed quickly from a small coastal town to a rich metropolis where commercial and industrial activities prospered. In addition it attracted an endless flow of calligraphers and painters. Here they set up art societies, engaged in discussion, and opened up a market for works of art. Shanghai became the nation's leading city as far as artistic activities were concerned.

During the century or so that followed, a great number of artists appeared on the Shanghai art scene, presenting a range of styles of painting. Some chose to follow ancient styles, extending the legacy of the Qing dynasty orthodox school. Others were bold enough to break existing conventions, and established individual styles in painting that were very much in pace with the period. These artists have been categorised in Chinese art history as the Shanghai School.

The masters of the Shanghai School introduced new elements to tradition and transcended it. Their choice of subject matter reveals everyday life and their works cater to the need of the new urban population and appeal to both the 'refined' and the 'vulgar'. In their artistic language these masters aimed for novelty, for a vivacious and robust use of brush and ink, and for brilliant and enchanting use of colour. By enhancing the visual appeal of their paintings they brought them closer to the ordinary person. Some borrowed a mode of expression from ancient scripts; others learned from Western painting. The Shanghai School of Painting reflects the culture of the modern city and made important contributions to the development of Chinese painting.

To present this important era in modern Chinese art the Shanghai Museum has selected fifty-nine works by masters of the Shanghai School to be exhibited at the National Museums of Scotland. It is our hope that this exhibition enables the people of Scotland to understand Chinese culture better and thus encourage further cultural exchange between Scotland and China.

Chen Xiejun
Executive Director
Shanghai Museum

Detail of Autumn Flowers, Plants, and Insects *by Zhang Xiong*.

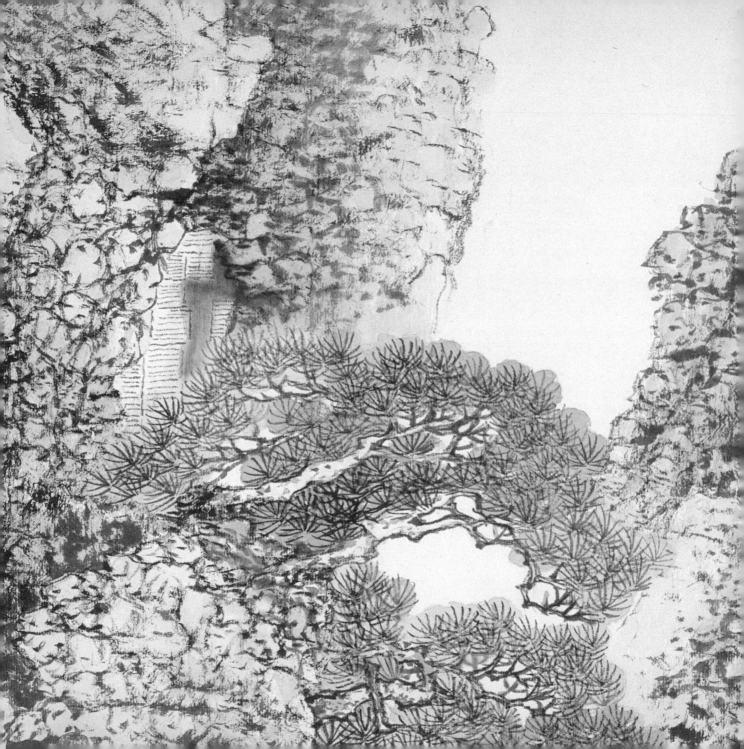

Preface

This exhibition of Chinese paintings from the Shanghai Museum is a rare opportunity. Chinese paintings, despite being easy to transport when rolled up, remained beyond the ken of most early travellers to China, and still remain unfamiliar, unlike Chinese porcelain, famous since the eighteenth century through the Canton trade. Foreign merchants in Canton, confined to their Hongs or warehouses on the banks of the Pearl River, diligently sought to learn about China's strange customs and exotic products, but had few chances of disseminating their own culture, except perhaps for the engravings and sample vessels they supplied to be copied by the porcelain workshops serving the export trade.

In Shanghai, on the other hand, Western ideas and knowhow, in medicine, photography, fashion and furnishing, shipping and banking, could more easily spread outside the foreign enclaves to the Chinese population. Trinity Church was built in 1847, barely four years after the opening of Shanghai as a treaty port. It is no accident that Shanghai, alone in China, is a city now boasting a world-class museum in which both the exhibits and the displays attract a global audience. In a recent exhibition at Sothebys, Scottish contacts with China were represented by a splendid model of a passenger ferry built in Leith for fast passages between Hong Kong and Canton, and by fine photographs of the 1890s showing the whole of the Bund and other scenes, assembled by Thomas Caldwell Anderson, manager of the Hong Kong and Shanghai Bank, whose father-in-law was James Finlay of Greenock, the owner of four tea clippers. Such photographs show a great awareness of the growing importance of Shanghai for trade: this exhibition, of paintings which were created solely for the home market and not for export, allows us a privileged view into the cultural life of the city.

The paintings in this exhibition reveal a lively artistic scene in late nineteenth-century Shanghai that is quite at odds with the conventional idea of a culture in decline at the end of the Qing dynasty. The versatility of the traditional Chinese materials, especially of brush and ink, conveys a view of China that is subtler and more diverse than the brightly coloured albums of products and costumes, or the wallpaper scenes of pavilions and birds and flowers, that had been staple items in the East India trade a century earlier. Some landscapes reflect the monumental compositions of the old masters, while some, like Zhao Zhiqian's *Bookstack Cliff*, are strikingly innovative in subject, composition and brushwork. A similar variety is to be seen in the figure paintings: Wu Guxiang's delicate, almost insubstantial contemporary beauty contrasting with the crisp features of Ren Xiong's *Lady of River Xiang*, a goddess from the distant past, detached on a plain ground, the clouds around her head frozen into an archaically intricate jade hairpiece, and the waves that should be at her feet fancifully woven into the broad hem of her dress: an image that in the mid twentieth century would inspire the leading painter Fu Baoshi to make his own rendering. Throughout, and especially in subjects such as flowers, birds, cats and fish, these paintings display the prized ability of the Chinese artists to convey the spirit of their subjects, bringing them to new life on paper or silk.

Roderick Whitfield
Percival David Professor of Chinese and East Asian Art
School of Oriental and African Studies
University of London

Opposite
Detail of Bookstack
Cliff *by Zhao Zhiqian.*

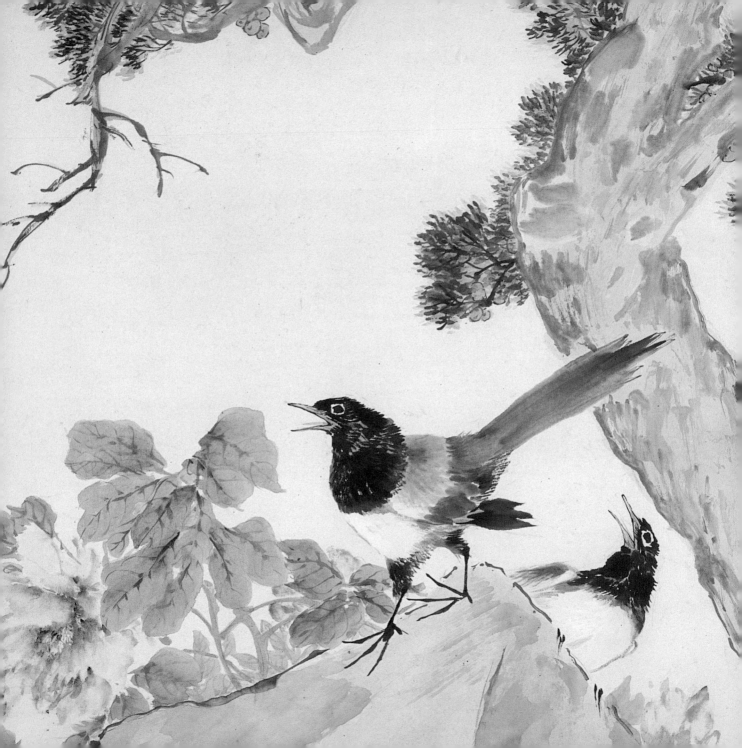

The Cultural Significance of the Shanghai School

Shanghai emerged as a metropolis during the late nineteenth and early twentieth century, where capital from China and from abroad gathered and local and foreign enterprises assembled. Many businesses and shops were opened, and trade prospered. Shanghai swiftly established itself, not only as the centre of commerce and industry in China, but also as a city important internationally in its financial and business activities.

The flourishing economy brought cultural development. Within a few decades, painters from all across the country poured into Shanghai where they sold their works to make a living. Among them were innovative artists who were able to break away from the confines of tradition. Adapting themselves to the demands of a new, modern city, they infused into their works the cultural characteristics of urban life. New styles were brought into being and became the vogue. These have been categorised in art history as the Shanghai School.

The Opening of Shanghai, The Booming of the Art Market

Shanghai is located where the Yangzi River flows into the sea. With the Eastern Sea to its east, a river to its north, Shanghai is cradled by the fertile plains of the Hangzhou, Jiaxing and Huzhou regions. In the early Qing dynasty (1644-1911) Shanghai was a small city, and its economy relied heavily on silk and tea production. After opening to maritime trade in 1684, Shanghai soon evolved into a busy trading port. But the Qing government prohibited sea trade once again in 1757, and the port city survived for a while on domestic trade and shipping. After the Treaty of Nanjing in 1843, Shanghai was declared a treaty port. Britain, America, France and other countries set up concessions there. The 1850s and 1860s witnessed frequent struggles between the Qing armies and the rebels of the Taiping Rebellion (1850-64). Consequently, landowners, officials, businessmen, and many others from Jiangnan swarmed into the foreign concessions in Shanghai, foreigners and Chinese living side by side. Within a short period population soared, creating an excuse for foreigners to demand the extension of their concessions. In 1898 foreign concessions occupied a total of more than 48,500 *mu* (approximately 29.75 square kilometres) of territory in Shanghai.

The foreign powers established self-governing systems in Shanghai. The year 1854 saw the establishment of the Municipal Council of the International Settlement. The French later withdrew to set up their own separate municipal council. Also established were a police department and the Foreign Inspectorate. From 1846 onwards the collection of foreign tariff duties was controlled by British, American and French inspectors. In 1864 the Mixed Court was founded in collaboration with the Qing government through which foreigners could participate in judicial matters. Under the protection of extraterritoriality, foreign concessions almost became 'nations within the nation'. Foreign investors came to Shanghai to set up banks and factories. They constructed bridges and roads and provided such public utilities as electricity, gas lighting, water supply, transport and postage. At the same time, the

Opposite
Detail of Peonies and Birds *by Wang Li.*

Qing government invested heavily in Shanghai by setting up banks, trade and manufacturing bureaus. Private enterprise prospered. Statistics show that the size of the city had increased more than thirtyfold between 1843 and 1914 and the population rose from 540,000 in 1852 to 1,200,000 in 1910. More than 140 provincial associations had been set up by merchants who settled temporarily in the city. Shanghai thus emerged as a cosmopolitan city.

A prosperous economy, a relatively stable environment during a period of domestic rebellion, as well as the high consumption power of the urban population – all these provided favourable conditions for artistic development in Shanghai. And according to the headcount of Huang Xiexun in his *Songnan Mengyinglu* of 1889, there were no fewer than 100 painters from different provinces who were famous in Shanghai.

Among the many professions and businesses set up in Shanghai were shops selling antiques, bronzes, archaic seals, calligraphy and paintings. The first calligraphy and painting shop in Shanghai, Manyunge (Stretching Cloud Pavilion), had been established as early as the ninth year of the Daoguang reign (1829). It was located in Ermalu (present-day Jiujiang Road). The Tongzhi reign (1862-74) saw the opening of many other shops selling stationery and fans: Guxiangshi (Studio of Antique Fragrance) on Ermalu, Jinruntang (Hall of Splendid Profit) on Baoshan Street (present-day Guangdong Road), Qingliange (Green Lotus Pavilion) and Deyuelou (Pavilion for Catching the Moon) in the Yu Garden, and Xihongtang (Great Performance Hall) on Henan Road South. During the Guangxu period (1875-1908), there were Jiuhuatang (Nine Flower Hall) (which had moved from Suzhou to Henan Road South in Shanghai), Liyunge (Beautiful Cloud

Pavilion) (located in the Yu Garden), as well as Duoyunxuan (Flowery Cloud Gallery) (founded in 1900 on Henan Road), and so on. These shops were centred in the Laochengxiang district in the southern part of the city or in the eastern part of the British Concession. These were bustling areas where population was dense and banks and shops were plentiful. The shops supplied paintings, colour pigments, papers, ready-made fans and other stationery items. Some of them also mounted paintings, provided lodging for visiting artists and allowed them to sell their works. Ren Yi (1840-95), for instance, stayed at Guxiangshi when he first arrived in Shanghai. He also sold his works on consignment there. Pu Hua (1832-1911), who came from Jiaxing, lodged and sold his paintings at Xihongtang. The emergence of these shops fundamentally changed the customary way of selling paintings. In the past, it had been the wealthy who commissioned paintings. Buying and selling were conducted privately or through agents representing the painters. The opening of an art market promoted the open selling of works of art.

Another important factor behind artistic activity in Shanghai was the founding of calligraphy and painting associations. In 1862 Wu Zonglin (19C) from Qiantang (present-day Hangzhou) came to Shanghai and formed the Pinghuashe (Duckweed Society) in Guandi Temple in the western part of the city. Participants included Wu Dacheng (1835-1902), Gu Yun (1835-96), Qian Hui'an (1833-1911), Wang Li (1813-79), Zhu Xiong (1801-64), Zhu Cheng (1826-1900), Tao Qi (1814-65), Zhou Xian (1820-75), Qin Bingwen (19C), and others. Pinghuashe's chairman was Gu Chunfu, vice-chairman Yu Yue, and it provided the basic structure of a professional art association. During the Tongzhi

period, the Feidange (Pavilion of Flying Painting) was founded in the Yu Garden. Famous painters such as Wang Li, Wu Qingyun (d1916), Hu Yuan (1823-86), Yang Borun (1837-1911), Ren Yu (1854-1901), Zhang Xiong (1803-86), Pu Hua, Wu Changshuo (1844-1927), and Wu Youru (1840-c1893) participated in the activities it hosted. Feidange was not only an art association where artists gathered and exchanged ideas but also a painting shop. It acted as mediator between painters and buyers, and provided an inn for travelling painters. The Haishang Tijinguan Jinshi Shuhuahui (Shanghai Tijin Association of Epigraphy and Painting) was founded in the 1880s, with Wang Xun (d1915) as the chairman and Wu Changshuo as vice-chairman. It attracted painters, calligraphers and seal-carvers. Its activities included studying antique bronzes, stone inscriptions, paintings and calligraphy, and promoting and setting price lists for the sale of works of art. Its activities continued well into the 1920s. The Yu Garden Charitable Association of Calligraphy and Painting was formed in 1909. Qian Hui'an was the founding chairman, while Wu Changshuo, Pu Hua, Gao Yong (1850-1921), Yang Borun and Wang Zhen (1867-1938) were founding members. A charter was written, and members were required to contribute financially to the association. It hosted activities regularly, organised artistic gatherings, set prices for commissions, helped newcomers to the trade, and participated in charitable activities. This was an institution that had clear objectives and manifested the characteristics of a common trade guild. It remained active until the 1930s.

Newspapers in late Qing Shanghai were places where artists could advertise their art. *Shenbao*, founded in 1872, often published verses to introduce readers to painters or carried advertisements for painting shops. An example is this, appearing on 18 June 1872:

> Qingyunguan [Blue Cloud Hall] is newly established in the middle of Baoshan Street. It specialises in the sale of portraits. Calligraphic works in a complete range of formats – scrolls, horizontal tablets, fans, and couplets – are all available.

And on 13 December of 1872, *Shenbao* published a series of quatrains in praise of contemporary Shanghai calligraphers and painters:

> In painting, the first to compliment is Li Daoren [Wang Li].
> He is superb in both floral and figural paintings.
>
> Hu Gongshou's [Hu Yuan's] brush and ink are graceful and easy.
> Zhang Zixiang's [Zhang Xiong's] floral sprigs are well composed.
>
> The Ren brothers [Ren Xiong (1823-57) and Ren Xun (1834-93)] followed the school of Laolian [Chen Hongshou (1598-1652)].
> Why don't they also take Songxue [Zhao Mengfu (1254-1322)] as their teacher?
>
> Then there is Bonian [Ren Yi] who is truly the legitimate inheritor [of the Rens].
> They are all wonderfully good.

In addition the pictorial *Dianshizhai Huabao*, a supplement of *Shenbao*, often carried illustrated advertisements for painting shops. These widely read newspapers helped spread the fame of artists.

Shanghai's very special political background, its unusual economic prosperity, the active involvement of art associations, the opening up of a commercial art market, the promotion by the news media – all provided favourable conditions for artists who sought their livelihood through the sale of paintings in Shanghai. The Shanghai School was born under these circumstances.

CONTINUATION OF ORTHODOX STYLES

Like an ocean into which many rivers flow, Shanghai attracted painters from all across the country. Natives of Suzhou and Zhejiang outnumbered those of other regions. Historically, Suzhou and the Zhejiang district had a strong link to the Wu School, the Four Wangs (Wang Shimin (1592-1680), Wang Jian (1598-1677), Wang Hui (1632-1717) and Wang Yuanqi (1642-1715)), Wu Li (1632-1718) and Yun Shouping (1633-90). Painters who grew up in these regions were deeply rooted in orthodox tradition. Meanwhile, many scholar-officials and gentry residing in Shanghai continued to favour the literati tradition of Chinese paintings, creating a big market for the orthodox style. Famous orthodox painters in Shanghai include Tao Qi, Wu Dacheng, Hu Yuan, Gu Yun, Wu Guxiang, Yang Borun (1840-c1897), Wu Tao (1831-1906), Sha Fu (1851-1920) and Lu Hui.

Excelling in landscapes, orthodox painters rose to prominence in Shanghai. Tao Qi, who came from Jiaxing, modelled his landscape paintings after the Four Wangs. Also influenced by Dai Xi (1801-60) of Hangzhou, his brush-style is free and elegant, his colours fresh and charming.

The Suzhou artist Gu Yun was a revivalist, and his works are said to have been 'nourished by tradition, synthesising the excellence of the Four Wangs, Wu [Li] and Yun [Shouping]'. With firm compositions and pale and elegant colouring, his works show his reliance on the literati tradition. Indeed, as recorded in the *Haishang Molin*, the Circuit Superintendent of Suzhou and Songjiang, Shen Bingcheng, invited Gu Yun to his home, where the artist painted for him every day.

Wu Dacheng was a person of wealth and status from Suzhou, whose family owned a great collection of ancient paintings and calligraphy. He held the high position of Governor of Guangdong and Hunan. In landscape painting he was a follower of the Four Wangs. He pursued in his works the uninhibited, the carefree, the fresh and the refined.

Yang Borun of Jiaxing followed Dong Qichang (1555-1636) when he painted landscape in a refined manner. His brushwork is fine and firm, fresh and moist. But when he painted more abbreviated landscapes, he modelled himself on Shen Zhou (1427-1509), following his free and sketchy brushwork.

Wu Guxiang, who also came from Jiaxing, was able to combine in his works the stateliness and freedom of Shen Zhou with the strength and intensity of Tang Yin (1470-1523). He also followed a recent model, Dai Xi. Wu's brushwork is strong and powerful, yet he lacks vigorous spirit.

A native of Chongde in Zhejiang province, Wu Tao was initially a follower of the Four Wangs. He later emulated the style of Xi Gang (1746-1803), absorbing, at the same time, the strength and boldness of Shen Zhou. His works tend to be vigorous, yet lacking in simplicity and subtlety.

Lu Hui from Suzhou was active from the late Qing dynasty through to the early days of the Republic of China. He followed the Four Wangs and, in particular, the brush idioms of Wang Yuanqi. In his landscapes he pursued feelings of expansiveness and freshness, absolutely free from any constraint.

The Shanghai painter Hu Yuan also followed the path of learning from ancient masters. His brushwork changed from free, sketchy and vigorous to comparatively soft and fluent as he aged.

All the above-mentioned painters strictly followed ancient methods. In composition they usually followed prototypes set by their predecessors,

imitating paintings rather than natural scenes. In the use of brush and ink, they conformed to traditional schemes. Even though they were able to change their styles – like Wu Dacheng (whose brushstrokes changed from heavy to dexterous in his final years) and Hu Yuan (whose texture strokes became robust, lively and varied) – they were still confined within the parameters of the literati painting tradition. Their landscape paintings fail to reveal the hubbub of a modern city – its prosperity, its rashness, its quick tempo, and the state of mind of a rapidly changing society. They remain the resonance of an established tradition.

Many orthodox painters excelled both in flower and bird painting, and figure painting. They took as their models the orthodox school master Yun Shouping and others such as Chen Shun (1483-1544), Xu Wei (1521-93) and Hua Yan (1682-c1765). They strove for such aesthetic qualities as gracefulness, refinement and harmony. In figure painting they inherited primarily the tradition stemming from Qiu Ying (1494-1552) of the Ming dynasty down to Jiao Bingzheng (late 17C-18C), Yu Ji (1738-1823) and Gai Qi (1774-1829) of the Qing dynasty – one advocating the elegant, delicate beauty of female subjects. In flower and bird painting they initiated some changes: brushstrokes were free and animated, colours were light and bright. They enhanced the visual effect with vivacity and luminosity. To a larger or smaller extent these changes reflect a tendency to adapt to public taste.

In Shanghai the traditionalists and the individualists did not form two opposing schools. On the contrary, there was quite a close relationship between them. It is from a profound understanding of tradition that the individualists got the

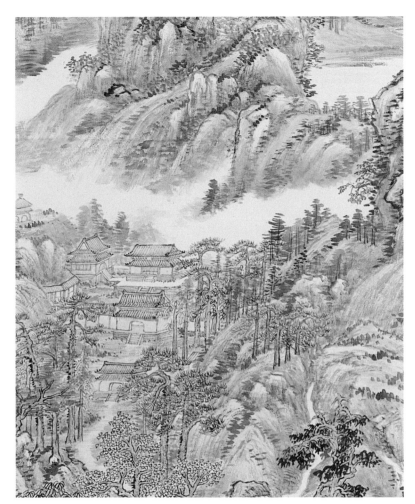

Detail from Clearing Clouds on the South Mountain *by Lu Hui.*

nourishment and inspiration for artistic production. The traditionalists pursued in their art the refined nature of literati tradition and the importance of brush and ink. What they manifested was the intent to defend traditional values, which in turn reveals the degree of open-mindedness towards cultural diversity in Shanghai.

In Response to the Times

In an attempt to adapt to the culture of a new metropolis, a large group of painters boldly moved away from tradition. What they manifest in art is a new vision of the world of nature and the world of man. They were also able to express their feelings and ideas, creating styles that are uniquely their own. This became a major trend of painting in Shanghai during the second half of the nineteenth century, and art historians commonly identify them as the Shanghai School. Representative painters include the Three Xiongs (Zhang Xiong, Zhu Xiong and Ren Xiong) – who lived slightly earlier – as well as Ren Xun, Ren Yi and Xugu (1823-96) of the golden age of the school. One must also include Wang Li, Zhu Cheng. Zhou Xian, Pu Hua, Qian Hui'an, Gao Yong and Ni Tian (1855-1919), who shared similar interests.

The Shanghai School has as its pioneers Zhang Xiong, Zhu Xiong, Wang Li and Zhu Cheng. Working primarily in the genre of flowers and birds, the foundation of their art rested in the Wu School and the school initiated by Yun Shouping. They also followed masters closer to their time, like Xi Gang and Zhu Angzhi (b1764).

Zhang Xiong had moved from Jiaxing to Shanghai as early as the 1840s. The composition of his flower and bird paintings was well balanced, and his brushwork was steady and firm. In the late years of his life the movement of his brush became easy and unrestrained, the application of colours changed from fine to agile, from meticulous to buoyant, from subdued to resplendent. This infused his works with freshness and charm. Zhang Xiong was very supportive of new painters. Wang Li, Zhu Cheng and Ren Yi were among those whom he helped. Zhang Xiong was able to sell his paintings for high prices: as the most popular artist in Shanghai, he received one *tael* of silver for each fan or album leaf. Zhu Xiong, who came from Jiaxing, was two years his elder, but he very much admired Zhang Xiong's works and became his student.

The style of Zhu Xiong's paintings is close to that of Zhang Xiong's but is more relaxed. Zhu Xiong's younger brother Zhu Cheng also studied with Zhang Xiong, but he learned too from Wang Li. He was able to combine the merits of both: the orderliness of Zhang's and the angularity of Wang's brushwork.

Wang Li came from Wujiang in Jiangsu province. He favoured a more dynamic composition, sharp and brisk brushwork, in which his art differed from the fine, gentle style of Yun Shouping.

These artists did not aim at the introspective and expressive qualities of literati painting. They were more concerned with the portrayal of animated forms in their natural state of being. By exercising extraordinary strength and freedom in the use of brush, and by applying colours in their brightness and luminosity, these artists catered to the current aesthetic preference of the general public – one that favoured vivacity and liveliness.

Ren Xiong was another artist from the early phase who brought painting closer to the public. He painted many popular images illustrating vernacular

literature. His compositions were unconventional and often inspired by folk prints. His style is simple and vivid. In order to highlight his subjects, he sometimes eliminates backgrounds. A typical example is the *Album after Poems on the Great Plum Mountain Resort* which he painted for his good friend Yao Xie (1693-1765). In technique he emulated Chen Hongshou, but he also followed the intricate depiction of Tang and Song masters. His line-work is firm and forceful, no matter whether applied to figures, flowers, or birds. All his subjects are delineated precisely, and the linear quality conveys ornamental beauty. In landscape he departed from the stereotypes of the Four Wangs, revealing his true feelings towards the natural world. A good example is the *Thatched Cottage of Lake Fan*, which he painted for Zhou Xian. The meandering streams, the rolling hillocks, radiant trees, the scattered architecture – the entire composition is complicated yet neat and orderly. His use of colour is fresh and original. With bright blue, green, red, purple and white trees, this autumn villa of the Jiangnan region is made dazzling. Ren Xiong abandoned the desolate flavour of traditional literati landscape. He infused his landscape with vitality and with natural flavour, offering the possibility of novelty in small-scale landscape painting.

Ren Xun's style is very close to that of his elder brother Ren Xiong. His creativity is most obvious in his late works in the flower and bird genre, characterised by dexterous use of the brush and diverse range of ink tones. This technique of combining *gongbi* (meticulous) with *xieyi* (literally, write out the ideas) styles was to exert great influence on Ren Yi.

Other contemporary artists were Zhou Xian and Pu Hua – both from Jiaxing – as well as Qian Hui'an

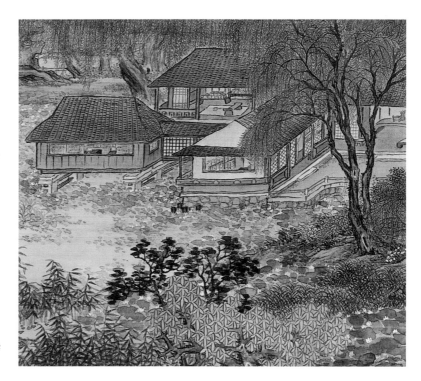

Detail of the Thatched Cottage of Lake Fan *painted by Ren Xiong for his patron-friend Zhou Xian.*

from Baoshan in Shanghai. In flower painting Zhou Xian followed the spontaneous and expressive styles of Chen Shun and Xu Wei. His originality in art is evident in his vigorous and forceful brushstrokes, brimming composition, heavy use of colour, and an overall free spirit in painting.

Pu Hua learned painting from Zhou Xian in his early years. His stylistic transformation occurred in old age when his brushstrokes became sketchy and abbreviated, resembling the dancing brush movement in the cursive script of Chinese calligraphy. His ink is usually wet and rich in tonal variation. Sometimes he preferred to use ink that had been left overnight, and for this reason his contemporaries call him 'Muddy Pu'. It is the unrestrained brushwork of Pu Hua that replaced the styles of the later followers of Yun Shouping which tend to become cloying and even vulgar. Pu Hua, instead, manifests in his art an unrestrained spirit, which reveals his carefree personality.

Qian Hui'an had become famous in Shanghai as early as the 1860s. He specialised in painting Buddhist and Daoist figures, auspicious subjects, as well as scenes to illustrate popular stories. Specific themes include immortals offering peaches of longevity, the Three Stellar Gods (of Happiness, Prosperity and Longevity), the God of Wealth, Guan Yu, and so on – all of which suited public taste. His short, vibrating and fluttering lines are full of rhythm, speed and movement. Although colours are applied onto the face to give his figural subject a sense of volume, it is not his concern to give a depiction that corresponds to anatomical understanding. His secularised figures inspired those of Ren Yi.

Of all painters, Ren Yi from Xiaoshan most displayed the vitality of the Shanghai School. At a very early age he learned portrait painting from his father Ren Hesheng. In his youth, he studied with Ren Xun. And after he had moved to Shanghai at the age of thirty, he learned how to sketch in Western style at the Tushanwan workshop of the Xujiahui Catholic Church. At the same time, he learned the techniques of other famous masters in Shanghai: Zhang Xiong, Zhou Xian, Hu Yuan, Wang Li and Qian Hui'an. He also learned from the ancient masters: Hua Yan's elegant and lively brush technique as well as Bada Shanren's (1624-1705) broad and expressive strokes. Ren Yi recognised the importance of sketching from life. Carrying a painting album in his pocket, he would sketch scenes he encountered, eventually producing over 1,000. He was extremely hardworking, and because he was good in synthesising what he learned, his artistic range was very broad. He could paint practically everything: episodes from mythology, from legends and from history; portraits; beautiful ladies; flowers; plants; birds; insects and landscapes. He could also depict figures of daily life: street pedlars, performers, boxers and ordinary citizens. He repeatedly painted several popular themes: the demon queller Zhong Kui, the Three Chivalrous Warriors, and the Cavalier's Reverie. As an artist living in an era in which the nation's fortune was in decline, these themes may express his concern over the future of his nation and its people. He also painted a variety of subjects enshrining auspicious wishes for prosperity, for longevity, for official promotion, and for warding off evil. His flower paintings are lively and often convey a delightful and light-hearted mood. He seldom chose to portray the traditional subjects favoured by the literati, such as plum blossoms, orchids, chrysanthemums and bamboo. In his choice of

subject matter, Ren Yi went a step further to expand the scope of the literati painting tradition. He was more interested in commonplace subjects – subjects that catered to the taste of merchants and of the populace in Shanghai.

Technically, Ren Yi was skilful in incorporating traditional methods with the new styles of his contemporaries and with Western representational styles, creating an artistic language uniquely his own. His portrait paintings show the infiltration of foreign technique: both the form and the facial features of his portraits are true to life. In figure painting Ren Yi paid special attention to the scheme so that the characteristic features of his figures stand out clearly in the narrative of human drama. In flower and bird painting his compositions are original, forms precise and lively. The techniques he employed are plentiful and varied: fine-line drawing, wet wash, dotting, and 'boneless' method (without linear definition of forms). Ren Yi could incorporate and utilise them with great ease. His method differs from the cool, untrammelled colouring of the literati tradition, from the heavy colouring of the academic tradition, and from the delicate style of Yun Shouping. Instead, he sought for freshness and luminosity in the application of colours. He was particularly skilled at using water and white powder to give a range of hues. Mixing together different pigments, he produced a spectrum of colours capable of creating a strong visual effect.

The art of Ren Yi enhances the visual appeal of pictorial representation, and was intended for the appreciation of the general public. His paintings were always in demand, and especially favoured by Guangdong and Fujian merchants. Even ordinary shopkeepers and hawkers were delighted to get something from his hand. Ren Yi's art manifests aspects of urban culture in this new metropolis – versatility, novelties, diversity, popularity – becoming a major component of the Shanghai School.

Xugu preserved more of the refined style of the literati tradition in his art. In his youth he served as an officer in the Qing army. At about thirty years of age he became a monk, which could be interpreted as a way of escape from the age of disorder in which he lived. As a monk, he did not chant prayers nor attend Buddhist rites, but spent most of his time painting. Perhaps because of Xugu's eremitic escape from reality in his life, his landscape paintings are heavily laden with feelings of seclusion. *A Long Day in the Silent Landscape*, for instance, expresses a desolate mood. He also favoured such themes as plum blossoms, orchids, bamboo, chrysanthemums and narcissuses, which traditionally carried connotations of the noble, refined qualities expected from the Chinese gentleman. He accompanied his paintings with poems, projecting onto these images his aloof character. Yet, on the other hand, Xugu had a deep passion for life in the natural world. He painted vegetables and fruits that evoke pastoral charm; animals like squirrels, goldfish, magpies, cats and birds that are full of movement and buoyant emotions.

To Xugu painting was also a way of obtaining social connections and his livelihood. Through art, he established friendships with Hu Yuan, Zhang Xiong, Ren Yi, Zhu Cheng, Qian Hui'an and others. Exchanges of poems and paintings between Xugu and these artists were frequent. According to the *Haishang Molin*, Xugu visited Shanghai and stayed there for several months, where patrons of his paintings often gathered in crowds. When Xugu felt tired of painting, he would leave. Because of the need to maintain a livelihood, he painted auspicious

Detail from Goldfish in Spring Water.
*With just a few strokes, Xugu outlines the
form of an object.*

subjects – pines, cranes, peonies, peaches, *foshou*
citrons, goldfishes with wisteria – which culturally
symbolise longevity, abundant happiness and official
promotion. Thus his range of subjects included both
the 'refined', and the 'vulgar'.

Stylistically, Xugu inherited the Anhui and the
Yangzhou traditions and was able to synthesise the
techniques of both for his own use. He learned the
brush technique of Hongren (1610-63) and Cheng
Sui (1605-91) and applied their dry brushstrokes –
which they used for landscape depiction – to his
renderings of flowers and birds. His brush idioms –
tremulous strokes, broken strokes, and strokes
applied in a reverse manner – evoke a sense of linear
rhythm. He was dexterous in using free, expressive
strokes, and with just a few strokes, outlined the
form of an object. In general, his paintings convey a
sense of coolness and freshness. They also encompass
multiple layers of meanings, characteristics that suit
both the 'refined' and the 'vulgar'. The linear
rhythm and the abstract flavour of his art typify his
breaking away from tradition.

Synthesising Western Elements

Western culture spread to Shanghai soon after its
opening as a treaty port. In the 1860s Western
missionaries founded a workshop of art and an art
school in Tushanwan, the Xujiahui Catholic Church.
It soon became an important centre for teaching and
practising Western art. Courses offered here included
sketches, sculpture and crafts. Tutors, Chinese and
foreign alike, practised Western oil painting and
watercolour and painted many religious images. For a
few decades the art workshop and school at Tushanwan
trained a number of painters to proficiency in
Western painting. The impact was far-reaching.

It has been said that Ren Yi was a good friend of Liu Bizhen, an officer working in the painting division of the Tushanwan workshop. Thus Ren Yi had the opportunity to use 3B pencils for sketching nude models. The existing corpus of Ren Yi's portrait painting shows his concern for the anatomy of the human face. He insisted on using the media favoured by the Chinese – lines and ink washes – when depicting the skeletal and muscular structure of the figure. Without too much emphasis on the contrast of light and shade, the image looks sculptural and convincing. Ren Yi achieved a reconciliation between Chinese and Western representational methods, and his results look more harmonious than the experiments by Giuseppe Castiglione (1688-1766) in the early Qing dynasty. Significantly, Ren Yi chose to preserve the formal elements of Chinese painting.

Wu Youru was one of the major masters painting for the pictorial *Dianshizhai Huabao* published in 1884-94. The lithographic prints for *Dianshizhai Huabao* are based on news reports of major events at home and abroad. They also illustrate customs and miscellaneous issues of everyday life. Besides Wu Youru, there were other contributors like Zhang Zhiying and Tian Zilin – all professional artists well versed in traditional Chinese painting but influenced by the Western religious images available at Tushanwan. Into a mode of expression consisting primarily of line they incorporated Western linear perspective and chiaroscuro to form a new style of secular painting: Wu Youru's *Ladies,* for example. At times he used linear perspective to depict architecture, furniture and vehicles. His female figures no longer wear ancient costume but fashionable dress of the day, giving his work a contemporary flavour.

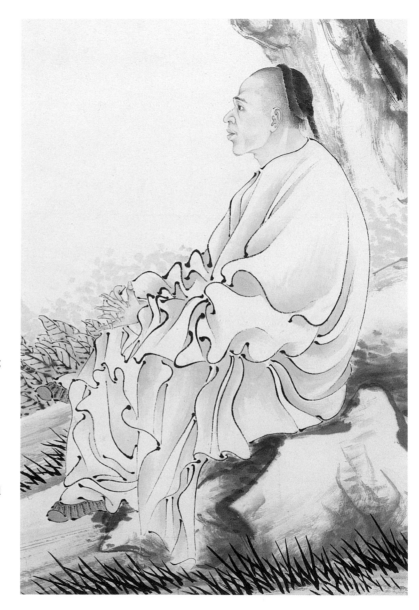

Detail from Portrait of Gao Yong by *Ren Yi showing the reconciliation between Chinese and Western representational methods in figure painting.*

Others influenced by Western methods include Wu Qingyun and Cheng Zhang (1869-1938). Wu Qingyun was a native of Nanjing who spent most of his life in Shanghai. According to the *Haishang Molin*, he was good at painting landscapes and could assimilate Western techniques into a style of his own. He was also able to incorporate the Western method of depicting landscape with traditional Chinese conventions, such as the cloudy mountains of Mi Fu (1051-1107) and Mi Youren (1086-1165) and the dotting method of Gao Kegong (1248-1301). He was particularly skilled in mixing ink with colours, using red or yellow to render the glow of rosy clouds. This technique was most suitable for his portrayal of the vapoury and misty scenery of the Jiangnan region. When depicting scenes at sunset he shows subtle changes of light in the moisture-laden atmosphere. His paintings were unique in Shanghai and were favoured particularly by wealthy merchants and compradores from Guangdong.

Cheng Zhang took a special interest in morphology and excelled in depicting animals, flowers, plants and insects. He applied the Western techniques of foreshortening, contrasting light and shade, and anatomical observation to his depiction of animals. In flower painting he tended to use the *zhuangfen* technique (adding white powder solution to areas that are still wet), a method that is closely related to that used in Japanese watercolours.

Painters of the Shanghai School borrowed Western representational methods for essentially Chinese paintings. They put into practice the late Qing ideology of 'Chinese learning as the basic substance, Western learning for practical use'. In this respect, they strengthened the representational aspect of Chinese painting, enriching its technical range and evoking a contemporary flavour.

THE RISE OF THE *JINSHI* SCHOOL

From the late eighteenth century onward, *kaoju* scholarship (textual research) and the study of ancient bronzes and steles was extremely popular. Bronzes from the Shang (c1600-c1100 BC) and Zhou (c1100-256 BC) dynasties, steles from the Qin (221-206 BC), Han (206 BC-AD 220), Wei (220-65), Jin (265-420), Sui (581-618) and Tang (618-907) periods were uncovered in large quantities, attracting enormous interest in art circles. Ruan Yuan (1764-1849) and Bao Shichen (1775-1855) advocated theories of calligraphic techniques based on stele studies, especially northern steles. This helped to ignite the popularity of the northern steles among calligraphers. Deng Shiru (1743-1805), Yi Bingshou (1754-1815), Chen Hongshou (1768-1822) and Bao Shichen were all notable representatives of the stele school of calligraphy. In seal carving, artists imitated seals of the Qin and Han dynasties; the three most important schools were the Hui School, the Zhe School, and the Wan School. The developments in calligraphy and seal carving reflected the change in aesthetic preference from perfected elegance back to rustic robustness.

Chinese painting shares essentially the same aesthetic principles as Chinese calligraphy. Thus changes in the areas of calligraphy and of seal carving stimulated a similar development in painting. A number of late Qing calligraphers and seal-carvers also practised painting. They incorporated the brush technique of the stele school of calligraphy as well as the knife-carving effect of seal carving into painting, creating the flavour of *jin* (metal) and *shi* (stone) as well as a vigorous momentum in painting. This new direction in art has been called the *Jinshi* School.

Zhao Zhiqian (1829-84) and Wu Changshuo were outstanding figures in this trend in the late Qing dynasty. Zhao Zhiqian mastered both

calligraphy and seal carving. In calligraphy he first followed the style of Yan Zhenqing (708-84) and later turned to clerical script and northern steles for models. He was able to synthesise the various scripts of Chinese calligraphy – seal script, clerical script, regular script and running script – to form a dignified and handsome style of running script. In seal carving, he first mastered the style of the Zhe School, from which he departed to explore in great depth the works of the Wan School master Deng Shiru. Referring also to ancient coins, to inscriptions on ancient mirrors, and to stone tablets, Zhao Zhiqian developed a novel and unusually forceful calligraphic style for seal carving. His word compositions are dense and solid, his carving for a single stroke is direct and for a turning stroke graceful, producing a style that is full, heavy, fluent and elegant. Because of his preference for things simple, heavy and solemn, Zhao Zhiqian did not turn to the orthodox masters – who pursued a relatively more refined, elegant style – as his models in painting. He followed, instead, the uninhibited styles of earlier masters like Bada Shanren, Shitao (1641-1710), Chen Shun, Xu Wei, Li Shan (1686-1762), Li Fangying (1696-1754), and even his contemporary Zhang Cining (b1743). He infused his paintings with the brush technique of his calligraphy as well as the momentum required in seal carving. The *Haishang Molin* remarks that he even applied the aesthetic conception of the seal and the clerical scripts to painting. His strokes were heavy, thick and full, and sometimes undulating and vibrating. He was painting – and indeed writing the strokes – as if working with a knife in seal carving, resulting in works with a strong sense of rhythm and movement. There is a boldness in his composition and colouring. His studies of the Qin and Han seals

explain his preference for rich and dense compositions. In colouring, he altered the style of Yun Shouping by using intense reds, greens and blues together to echo a wide range of ink tones.

In terms of subject matter, he painted flowers and plants that symbolise the noble character of a gentleman – plum blossoms, orchids, chrysanthemums and bamboo – as well as those appealing to the general public because of their association with prosperity, fortune and longevity – peonies, wisteria, lotuses, peaches. To these auspicious subjects he added inscriptions to convey good wishes. His paintings appeal to both the 'refined' and the 'vulgar' and thus, as commented in the *Haishang Molin*, people contended for his paintings as treasures when he travelled to Shanghai.

After Zhao Zhiqian, it was Wu Changshuo who brought the *Jinshi* School to a new peak. Until his middle age, Wu Changshuo's achievement in art was mainly confined to the areas of calligraphy and of seal carving. He learned the seal script from Yang Yisun (1812-81). Then he concentrated on the studies of stone drum inscriptions and northern steles, as well as the regular script of the Tang calligrapher Ouyang Xiu (1007-72). In his later years, he employed the calligraphic technique of stone drum inscriptions in running and cursive scripts, which gave his writing extraordinary force and archaic beauty. In seal carving he combined the best from the Zhe and the Wan schools. He consulted the works of Wu Tingyang (1799-1870) and Zhao Zhiqian, gaining the essence of Qin and Han seals in his works. He was good at using a blunt knife, and his style was simple and vigorous.

Wu Changshuo only started to paint after the age of thirty. He was involved in the study of traditional paintings, learning especially from Chen Shun, Xu

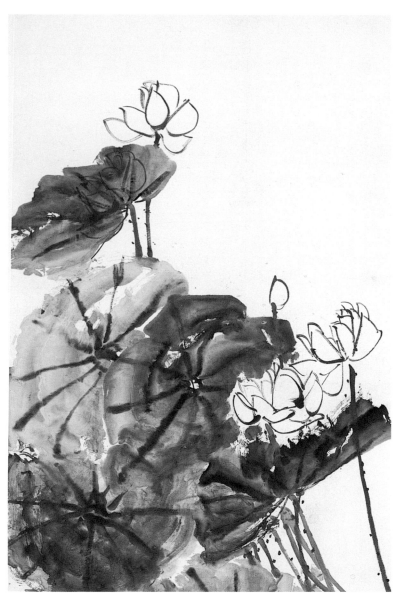

Detail from Ink Lotus *by Wu Changshuo.*
The diagonal composition forms a drastic
contrast of solid and void.

Wei, Bada Shanren, Li Shan and Zheng Xie (1695-1765). He also learned from Zhang Cining, Wu Xizai and Zhang Xueguang (d1861), who lived slightly earlier, and from his contemporaries Zhang Xiong, Zhao Zhiqian, Ren Yi and Pu Hua. He took the very essence of their art to form his own foundation for painting. From his sixtieth year onward, his art matured.

In Wu Changshuo's own words, 'Kutie [his sobriquet] paints *qi* but not form.' What he meant was to attain *qipo* (vigorousness) and *qishi* (energy-momentum) on the picture surface. When realising these concepts in a composition, he tended to use unusual and extraordinary pictorial structures. Often he preferred to use a diagonal composition, with the subjects concentrated on one side or a corner, forming a drastic contrast of solid and void, density and sparsity. Sometimes he placed massive rocks against creepers to create a polarity between the unyielding and the malleable. He sought for the manifestation of spirit and liveliness through forms, but not formal likeness. For example, his rocks are strange, antiquated and crude, not delicate and pleasing. His plum blossoms have iron-like branches and dense groupings of flowers, emitting tremendous force and free spirit. His ink bamboos are upright and unyielding, orchids pure and unworldly, chrysanthemums solid. An important feature of Wu Changshuo's painting is its infusion of ancient calligraphic elements. He advocated 'the combination of the methods for painting and for seal carving'. When he wielded the brush he held his fingers tight but the grip of his palm remained loose. He raised his lower arm and held the brush vertically so that the tip of the brush would be concealed in the centre of each stroke. The force is vigorous and the energy intense. At times the strokes in his painting

are as firm and powerful as in his seal script; at others they are in a dancing movement and are as free as in his cursive script. Light or weighty, slow or speedy, forceful or gentle, crude or refined – his brush methods are combined to make up a series of harmonious rhythms. Wu Changshuo worked primarily in ink painting where the tonal variation of ink is rich and the wielding of the brush apparent. In his late years, he boldly employed intense colours: the Western red, lemon yellow, brilliant blue, heavy ochre and deep green. Contrasted against the colours of ink, they are brilliant.

Wu Changshuo extracted from the ancient scripts modes of artistic expression that are unusually strong, antique and rustic. He created an original style full of vigour and force. What he expressed in art is intense emotion and unwavering faith, and this could be understood in the context of dynastic decline and foreign invasion at that time, which roused Chinese scholars to strengthen their styles.

If we say that artists like Ren Yi, Xugu and others were leading masters who began a new era in painting from the 1870s to the 1890s, then Wu Changshuo pushed the Shanghai School to another stage. The former opened up new frontiers by introducing fresh and vivacious styles to Chinese painting, while the latter pursued a vigorous, robust style.

Shan Guolin
Chief, Department of Calligraphy and Painting
Shanghai Museum
(Translated by Susan Y Y Lam)

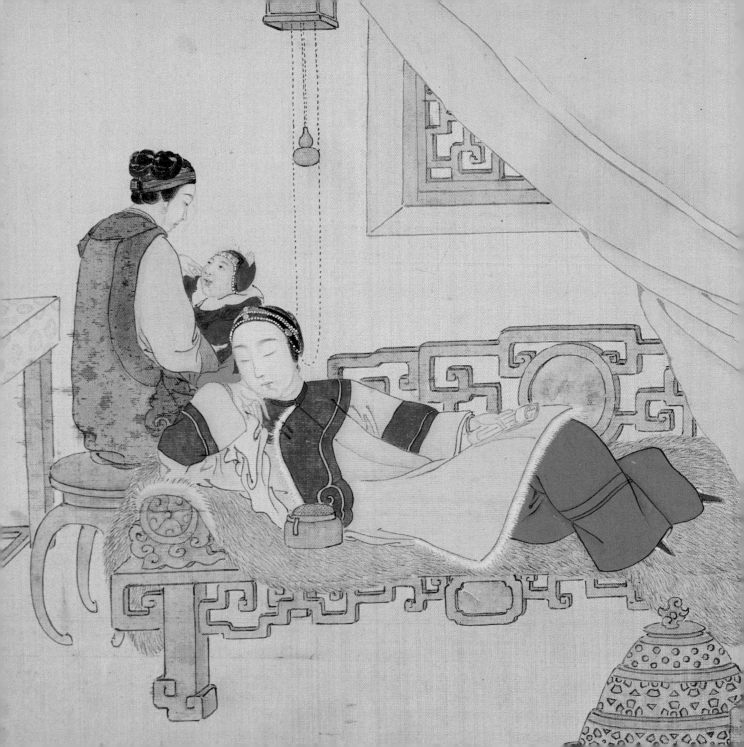

REINTERPRETING THE SHANGHAI SCHOOL OF PAINTING

In 1997, when a set of four large panels of Chinese paintings depicting the Guangzhou (Canton) waterfront was displayed in the exhibition 'Precious Cargo', the public was impressed by this monumental piece of Chinese art. Painted on paper by Chinese artisans for interior decoration, these export paintings were described as precious 'Chinese wallpaper'. The term indicates how these pictures were displayed and enjoyed in Britain. They were posted on the walls of a room, not unlike the *tieluo* paintings used to embellish the Qing imperial palaces.[1] Export painting – a type of Chinese painting commonly found in Britain – often features distinct subject matters and styles to suit Western tastes. If this is only a subdivision of Chinese painting intended for the Westerners, then what about the larger corpus produced for the Chinese themselves and for the Japanese and Korean buyers?

Before we look more closely at Chinese painting, it is important, first, to guard ourselves against the tendency to assume that native pictorial traditions were static. The dualistic relationship between continuity and change has formed the pattern of evolution of a long history of Chinese painting. Past traditions provided the Chinese artist with a source of inspiration as well as a point of departure. But these traditions were constantly changing, due partly to internal dynamics, partly to external influences. Transformations were not necessarily generated from within China, as the earlier reference to Westernised export painting indicates.

Thus the development of Chinese painting should be understood in a broader context of social and cultural change, which displays the complex interactions between old and new, native and foreign. This points directly to the foremost questions in relation to this study of the artistic developments in late Qing Shanghai: how do the differing artistic directions echo the changes that are taking place in society? How do these enable us to understand the Shanghai School of Painting?

The various artistic trends to be discussed in what follows are set within the time frame 1850 to 1911. The establishment of 1850 as the beginning of a new era in the Shanghai art scene is justified by the influx of great numbers of artists into the city during the second half of the nineteenth century, especially after the outbreak of the Taiping Rebellion (1850-64). But the emergence of Shanghai as a major art centre was also a result of economic prosperity brought about by trade prior to 1850. Shanghai's economic and social developments have often been discussed in relation to the opening of the city as a treaty port after China's defeat in the Opium War and the subsequent Treaty of Nanjing in 1842. Studies have called into question the utility of the Opium War as a major watershed for understanding the history and socio-economic development of Shanghai, as this may lead to excessive emphasis on the new elements under foreign influence and thus an overlooking of indigenous developments prior to the war. While there is no reason to deny the Western impact – and, indeed, the 1850s witnessed the internationalisation of Shanghai – it is equally significant to note the persistence of older cultural elements in this treaty port. We will consider both

Opposite
The ladies depicted by Wu Jiayou were extremely popular in Shanghai.

old and new elements in the making of late Qing Shanghai, and it is within this complex cultural framework that Shanghai's artistic developments will be examined and the term Shanghai School of Painting will be reinterpreted.

THE MAKING OF SHANGHAI

It is often said that Shanghai was initially a small fishing village, and the opening of the treaty port to foreign trade turned it into a modern metropolis. Recent scholarship has attempted to dispel this myth by examining Shanghai's development prior to the Opium War.[2] In fact, Shanghai had held an important position in trade and commerce since the early and middle Qing dynasty (1644-1911). The prosperity of the city was by no means associated only with international trade with the West. Well before the arrival of the Westerners a lively internal trade flourished in the bustling port city; the picture was quite the reverse of the conventional image of Shanghai as a fishing village.

Lying on the Yangzi Delta, Shanghai was a leading port city in Qing China. The city had been a major centre of the cotton handicraft industry since the Ming period. The lifting of Ming prohibitions on maritime trade by the Qing government in 1684 increased Shanghai's opportunities for trade. It emerged as a major coastal port, with northern and southern shipping routes linking it not only to other port cities along China's coast but also to ports as far as Japan, Korea, the Ryukyus and the Annam-Nanyang regions.[3] Major commodities shipped out of Shanghai included cotton fabrics, silk, fertiliser, foodstuffs, tea, agricultural produce and handicrafts from the entire Yangzi region; imports included birds' nests, paper, tobacco, knives and so on. A substantial amount of the trade passing through Shanghai was destined for the internal market. Foreign trade with Korea, Japan and Nanyang was overshadowed by the massive internal trade during the early and middle Qing period.[4] Commerce with the West was indirect and was restricted to the single port of Guangzhou (Canton) prior to the Opium War.

Merchant Guilds

Shanghai was a city of merchants. A great many people from other parts of China, or outsiders, were drawn to Shanghai by the lure of trade. The merchant element gradually came to dominate the social and economic spheres of the city. Merchant groups from various places such as Chaozhou, Guangzhou, Ningbo, Shaoxing, Huizhou, Quanzhou, Jiangxi, Shaanxi, Shandong and Liaodong formed associations or guilds based on their places of origin or on common trades and crafts. Often, native-place associations (*huiguan*) and common-trade associations (*gongsuo*) overlapped because merchants coming from the same native-place tended to engage in the same trade or to do business together. The existence of these merchant guilds was a special feature of Shanghai's urban ecology in the eighteenth and nineteenth centuries. They divided the city's immigrant population into regional and occupational communities, with the group boundaries marked by dialect, cuisine, opera and customary religious observances. The construction of guildhalls and gardens was further visible expression of the subdivision.[5] The diversity of China was here concentrated in one locality – Shanghai. And because of the existence of these social and economic units, Shanghai was almost 'a miniature of all of China', encompassing an ethnically diverse Chinese population.[6]

The presence of commercial guilds in nineteenth-century Shanghai had important implications for the

social transformation of Qing China. Under the class hierarchy in traditional China, merchants were ranked at the bottom in accordance with the order of scholar-official, farmer, artisan and trader. In Qing Shanghai, however, merchants could be wealthy enough to buy the Yu Garden and donate it to the City Temple, implying that they had sufficient economic power to provide the city with public space. These generous donors were the big merchants of Shanghai: shipowners and long-distance shipping merchants.[7] In addition, commercial guilds played an increasing role in local government and were important contributors to public welfare. Corporate donations to benevolent institutions (like the Tongrentang and the Yuyingtang) were not uncommon. And in the provision of social and charitable services, trade associations often extended their services to the whole community, not just to their members.[8] Such expansive practices of commercial guilds suggest that merchants were increasingly asserting their authority and status in society. Their institutionalised public services set the example for the future Yu Garden Charitable Association of Painting and Calligraphy. More importantly, as Shanghai rose as a centre of commerce, the old social balance of power was changing.

The construction of guildhalls was a visible expression of the division of Shanghai's immigrant population.

The Westernised Treaty Port

The coming of the Westerners transformed the treaty port in many ways. International trade with the West was conducted directly at Shanghai. Profits generated from international trade, which used to flow into Guangzhou under the Cohong monopoly, were to be shared with Shanghai. Statistics show that foreign trade at Shanghai surpassed that at Guangzhou soon after its official opening.[9] Chinese

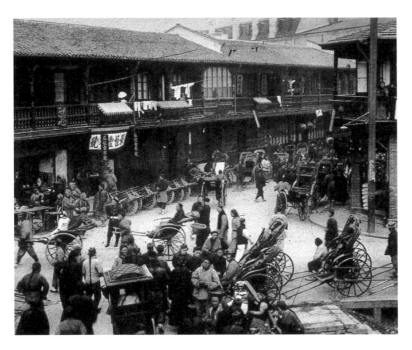

Late Qing Shanghai was a bustling city of trade and commerce.

merchants were aware of the rich opportunity of foreign trade and flocked to Shanghai. The Cantonese, who had previously dealt with the foreigners at Guangzhou, were quick to come, and many served as compradores or middlemen between European and Chinese businesses in Shanghai. Others from Ningbo and Fujian also seized the opportunity. There were, in addition, poor workers, boatmen and coolies coming to search for jobs. The increasing immigrant population compounded the already crowded environment of the city.

The corporate nature of Shanghai – marked by the pre-existing Chinese merchant guilds – was felt even more strongly with the arrival of such foreign trading companies as Jardine, Matheson; Gibb, Livingston; Dent and Company; Russell and Company. Under the protection of extraterritoriality (foreign legal jurisdiction over foreign nationals, a principle covering not only their persons but also their properties and servants), a foreign municipality was set up. Foreigners residing at Shanghai included the British, Americans, French, Russians and others. They constructed their own buildings, churches, cemeteries, and recreational facilities like racecourses and parks within the International Settlement. Although the act of trading in Shanghai made the foreign communities fit into the pre-existing immigrant and mercantile culture of Shanghai, the impact of the West as a result of this encounter was significant.

The foreign presence in the treaty port brought China closer to the outside world in many ways. In Shanghai the many indications of China's modernisation under the Western stimulus included newspapers, schools offering instruction in Western languages and sciences, libraries with collections of Western books, water supplies and sewerage, paved

and illuminated streets, railways, cables and arsenals – all were institutions of the urban West. Western material culture or lifestyle also became a new status symbol in the treaty port. Notably, Shanghai's foreign settlement was reserved for foreign use. But with the massive influx of refugees into Shanghai during the Taiping Rebellion, it was almost impossible to keep the Chinese out. After the unrest, those who finally resided at the International Settlement were the wealthier ones – mostly traders – who could afford to pay the exorbitant rents pushed up by speculators.[10] Participation in the foreign way of life became a new status symbol among the Chinese population.

However, the spectacular evidence of cultural borrowing from the West should not mislead us into thinking that the treaty port was transformed entirely into a modern cosmopolitan city. Although the Western impact was felt directly in Shanghai, exposure to modern Western institutions did not necessarily result in institutional changes and true cosmopolitanism. The situation was further complicated by the fact that the immigrant population in late Qing Shanghai did not necessarily identify themselves with this new metropolis but rather with their places of origin through native-place associations.[11] The urbanity of the Shanghai population might still remain on a provincial rather than a cosmopolitan level. Moreover, the Chinese population was living essentially in a Confucian state and society where traditions persisted and ruled supreme. Yet we can clearly establish the development in Shanghai of new commercial and international orders which began the long-term process of undermining the old institutions of Chinese society. The full impact of the West had to await the collapse of the Qing dynasty.

The Cultural Mosaic

Shanghai in the Qing era was a highly diverse urban metropolis. The population was a matrix of social class, locality and nationality. Social divisions were complex and overlapping: at times they were blurry; at other times distinct. There were social elites as opposed to non-elites; Shanghai natives as opposed to sojourners; Chinese people as opposed to foreigners. Because of this diverse nature of Shanghai's population, there existed a mixture of cultures: elitist cultures, popular cultures, regional cultures, and an exciting interaction between them. With accelerated social change and the Sino-Western quality of the city, there existed a mixture of things old and new, native and foreign: pre-existing Chinese institutions, new social organisations, shifting hierarchies of class, Western imports, and so on. The residents of Shanghai lived between different cultures and systems, and cultural and social ambivalence was part of the daily experience in this treaty port. As Frederic Wakeman, Jr and Wen-hsin Yeh have noted: 'This ambivalence is one reason why it was difficult to come up with a sense of community in Shanghai, even though its urban culture was so fascinating in and of itself.'[12]

The coexistence of various communities and cultures also meant that tensions and conflicts were inevitable. Realising her military weakness after the defeat in the Opium War, China initiated the Self-strengthening Movement. The ideology of reform was reflected in the slogan 'Chinese learning as the basic substance, Western learning for the practical use'. The policy pursued was actually a hybrid product of old and new, emphasising selective learning from the West, mainly in areas of science and technology, in order to restore the existing Confucian order. Moreover, in Shanghai the duality

In Shanghai there existed a mixture of cultures and an exciting interaction between them.

of the Chinese city and the foreign municipality created ethnic tensions among Chinese people and Westerners, resulting in the anti-foreign riots in 1874 and 1898. When the growth of foreign settlements meant the loss of burial lands of the Siming *gongsuo* (the guild of Ningbo merchants), struggles over land turned into anti-foreign protests that have been interpreted as the first buddings of popular Chinese nationalism.[13] Tensions and conflicts existed as a result of the encounter between different peoples and cultures, yet they often created conditions for new developments.

In brief, Shanghai was a bustling city of trade and commerce in the second half of the nineteenth century. The undertakings of merchants marked the corporate nature and enterprising spirit of the city.

Shanghai was also a place of encounters between groups of people. It mixed together peoples from different social strata, from all over China, and from various nations. With the metropolitan tolerance of cultural diversity, different cultures existed side by side, yet this cultural mosaic also featured tensions.

SHANGHAI'S INK FOREST
What happened to the Shanghai art scene during the late Qing period?

A prominent feature was the emergence of numerous artists in the city. The Qing art critic Yang Yi (1864–1929) compiled a catalogue of artists active in Shanghai in his book *Haishang Molin* (*Shanghai's Ink Forest*). He recorded more than 600 artists in the

Qing period, the majority of whom were not natives of Shanghai. In other words, it was travelling artists who made up the core of the Shanghai art community.

Geographical mobility of population was not a new phenomenon in Qing China; people often left home to seek opportunities elsewhere. In late Qing China, however, this trend was intensified by domestic turbulence. Great numbers of gentry refugees flocked to Shanghai, especially in the early 1860s when the Taiping forces advanced through the Jiangsu and Zhejiang areas. Shanghai was not attacked by the Taiping rebels, and so there was a rapid growth of the city's population through the arrival of refugees.

Not all artists migrating to Shanghai came in the early 1860s. Some arrived earlier or later. We may use the activities of two influential figures – Hu Yuan and Zhang Xiong – as examples. Hu Yuan had been active in Shanghai as early as 1855.[14] Zhang Xiong settled in Shanghai around 1862, after the Taiping Rebellion had spread to his hometown in Jiaxing:[15] according to the *Haishang Molin*, he had settled in Shanghai for the longest period of time.[16] Hu and Zhang represented an older generation of sojourning artists who had become famous in Shanghai during the second half of the nineteenth century. These two well-established figures played an important role in providing guidance and assistance for artists who arrived later – and there were many of them.

Why did artists flock to Shanghai?

Shanghai's commercial environment, wealth and dense population laid the economic foundation for artistic growth and drew a great many artists to the city to sell paintings. According to the contemporary art critic Zhang Mingke (1828-1908):

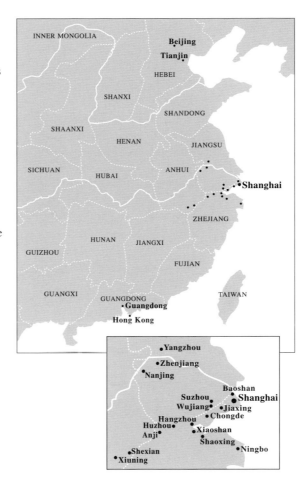

Since the lifting of the ban on maritime trade in Shanghai, no other cities could rival Shanghai in terms of prosperous trade. Those who earn their living by means of calligraphy and painting sooner or later come to the city, selling their works and residing there.[17]

Moreover, the preface to the *Haishang Molin* by another prominent Shanghai artist, Gao Yong (1850-1921), says:

There are numerous calligraphers and painters working in the great area along the grand river [Yangzi River]. Those who stay in their hometowns

and live in lofty seclusion remain unknown. But those who travel around and follow current trends must visit Shanghai.

For artists Shanghai was a place of economic opportunities, and so many of them left home and settled in the city. Others, while spending most of their time in their hometowns or in other urban centres in Jiangsu and Zhejiang, travelled occasionally to Shanghai to sell their works. Strictly speaking, sojourners or itinerant artists were not Shanghai artists. Their reputations were nevertheless linked to the city of Shanghai – the focal point of artistic developments in the late Qing. For example, Ren Xiong's reputation is that of Shanghai artist, but he was a native of Xiaoshan, Zhejiang province. He travelled extensively to Hangzhou, Jiaxing, Suzhou, Ningbo, Yangzhou, Nanjing, and to Shanghai only occasionally, finally dying in his native-place Xiaoshan. This was also true of his younger brother Ren Xun who developed his artistic career mainly in Suzhou and only made periodic visits to Shanghai. Zhao Zhiqian, a native of Kuaiji, never lived in Shanghai for any length of time, yet he too is known as a Shanghai artist. An artist's sojourn in Shanghai might be brief, yet they, together with those born in the city, made up 'Shanghai's Ink Forest'.

ART ASSOCIATIONS, FAN SHOPS, AND OTHERS

The arrival of numerous artists led to the establishment of many art associations or art societies in Shanghai. It might appear that artists were continuing with the old practices of literary and artistic gatherings in which kindred spirits met and interacted with each other. But the nature of these art associations had changed. Art societies differed from traditional artistic gatherings in playing an economic role in the commercial environment of Shanghai.

The Duckweed Society

Pinghuashe, or the Duckweed Society, was set up in Shanghai during the Xianfeng era (1851-61) by Wu Zonglin, a poet, calligrapher and painter from Hangzhou. Initially a poetry society, it developed into a painting society in 1862. By 1864 the society had held seven gatherings and had a total of twenty-four members. The seventh gathering, in 1864, was recorded pictorially by three artists – Qian Hui'an, Bao Dong (19C), and Wang Li – in a work entitled *Elegant Gathering of the Duckweed Society*. It was inscribed with a long passage by the founder Wu Zonglin. According to Wu, the creation of this art society was to gather together famous artists from Jiangsu and Zhejiang for the pursuit of cultural activities.[18] Given the importance of Shanghai as a place of temporary sojourn, however, such a society did not seek merely to promote cultural activities as it proclaimed. It seemed also to play a significant role in strengthening sojourning networks through the members' common interests in the arts, and the feelings of collective belonging which it generated were significant. This was true for traditional elegant gatherings in which sentiments were tied to shared interest, learning and social position in an exclusive way. But in Shanghai a sharpening of the artists' sense of identity as members of a social group could play an extra role in promoting sojourning networks. In this connection, it is noteworthy that the founder of the Duckweed Society and most of its members were not natives of Shanghai. As the members were mostly professional painters, there was also a relaxation of earlier concerns for learning and class distinctions in these social gatherings. Thus the Duckweed Society was a transitional type of society. It represented the shift from elegant gatherings to formal and professional organisations for artists.

While traditional practices were still pursued in this art society – such as recording the gathering pictorially and poetically – it was also moving towards new frontiers.

Further evidence for the change was the organisational structure of the Duckweed Society. In the past, the host-guest relationship was reinforced by the venue; literary and artistic gatherings took place and were named after the host's residence. By contrast, the activities of the Duckweed Society were held in a house-boat within a Daoist monastery in the western part of the city.[19] In Yang Yi's account, this monastery is mentioned as the Guandi Temple.[20] Wu Zongli was the founder and two other artists – Gu Chunfu and Yu Yue – were the chairmen. The changes from host-guest relationship to that between founder-chairman and member, from private space to public space, differentiate the Duckweed Society from the traditional elegant gathering. And although many writings regard the gatherings held at Li Tingjing's (d1806) Pingyuan Shanfang (Mountain Lodge of the Level Distance) and at Jiang Baoling's (1781-1840) Xiao Penglai Ge (Pavilion of the Little Fairyland)[21] as two earlier examples of art societies in Shanghai, these were indeed different from the Duckweed Society. Significantly, the local tradition of literary and artistic gathering was undergoing important changes in the second half of the nineteenth century.

Fan Shops

Besides formal art societies, other commercial art institutions also flourished. In late Qing Shanghai one could place orders for paintings at fan shops, which were also gathering places for artists. Xiang Yao (19C), a Taicang painter of floral subjects, set up a fan shop in the Yu Garden in Shanghai. The famous poet Yao Xie (1805-64) named it the Pavilion of Flying Clouds. This fan shop was, according to Yang Yi, a place where famous artists in Shanghai frequently held their artistic gatherings.[22] Another fan shop was set up by Yin Baohe's father (19C) at the former site of the Pavilion for Catching the Moon, also in the Yu Garden.[23] This fan shop, named the Pavilion of Flying Painting, was something like a club for artists. It not only supplied painting materials but also catered to their day-to-day needs. One could relax and practise painting and calligraphy there.[24] It is said that the pavilion also functioned as an inn for sojourners, and the famous painter Ren Yi painted there in his early years at Shanghai.[25] In addition to fan shops, there were mounters' shops and brush and paper shops that served also as agents for artists.[26] The painters Xugu and Ren Yi, for example, were friends of Zhu Jintang, owner of the Jiuhuatang stationery shop. Friendship, cultural ties and commercial interests were obviously intertwined.

The Shanghai Tijin Association of
Epigraphy and Painting

The integration of economic, social and cultural practices in fan shops and other commercial institutions points to the need of formal art associations to extend their functions in order to promote the interests of artists. As members were mostly professional painters who relied on the sale of paintings for their livelihood, art associations began to include activities relating to commercial transactions. This turned art associations more and more into commercial organisations.

The Shanghai Tijin Association of Epigraphy and Painting was set up in the late nineteenth century.[27] Wu Changshuo was one of its leading figures. The

In the vicinity of the Yu Garden were numerous shops selling antiques, paintings and calligraphy.

association was named after the act of *tijin*, the making of inscriptions on each other's collar or lapel when good friends meet. This was a polite convention practised by the *jinshi* calligraphers and painters. The term *jinshi*, literally metal and stone, refers to the study of epigraphy, especially ancient writings on bronzes and steles as a source of inspiration in painting and calligraphy. Obviously, as the name suggests, sharing of knowledge and appreciation of ancient writings among friends were the principal purposes of this association. Yet it also conducted commercial activities like fixing prices for works of art and introducing artists to patrons.[28]

The Yu Garden Charitable Association of Calligraphy and Painting

The establishment of the charitable association of calligraphy and painting (*shuhua shanhui*) at the beginning of the twentieth century truly transformed the art society into a new form of social and economic organisation. The Yu Garden Charitable Association of Calligraphy and Painting was set up in 1909 on the site of the Pavilion of Flying Painting, the fan shop owned by the Yin family, which had previously been closed. The most important feature of the Yu Garden Charitable Association was the combination of artistic activities with social and charitable services. In the charter for the association, published in the *Haishang Molin*, its author Gao Yong first addressed two contemporary trends in Shanghai: the trend of charitable activities; and the trend of art consumption motivated by the need to assume an air of refinement and to preserve the best of native traditions. Believing that artists should neither mingle with ink and brush only nor work on their own, Gao Yong then called for collective efforts of painters to help the needy and to support

the restoration (*weixin*) of Chinese tradition. Also in the charter were fixed prices for the members' works of art, depending on size and format. In addition, the works were to be done collaboratively in order to encourage diversification. The rule for moistening the brush – payment – was that artists shared their returns with the association at a rate of 50/50. Their collective savings would then generate interest, mainly used for charitable purposes.[29]

Although the charter was drafted by Gao Yong, the idea of setting up such a charitable association was shared by a group of artists in Shanghai. Qian Hui'an, Yang Borun and several others served successively as the chairman of this association. Moreover, although some of the artists included in the present exhibition had died by the time this association was set up, their names were included in the *Haishang Molin*, published by the Yu Garden Charitable Association.

Several aspects of the Yu Garden Charitable Association deserve special attention. First, its establishment denotes the growing commercialisation of Chinese painting at the close of the Qing empire. Artists acknowledged the monetary value of their works. They showed their enterprising spirit by setting up the association, drafting its charter, formulating agreed policies, and allocating funds to meaningful social activities.

Second, when artists operated jointly as an occupational organisation, their collective identity as professional painters was sharpened. It was stated earlier that art institutions in Shanghai played an extra role in strengthening ties among artists who were mostly sojourners. By taking care of the day-to-day concerns of artists, art societies were creating a supportive environment for sojourners in Shanghai. Just as elegant gatherings had been the

mechanism for establishing social networks among the elite, art associations were an outward expression of the affiliations of professional painters. In the latter case, painters – many of whom were travelling artists – were connected also through commercial activities. The Yu Garden Charitable Association maximised the degree of mutual support through collaborative efforts in artistic, social and charitable activities. Artists worked more and more in the manner of a large organisation.

Third, the sentiments that linked the artists together were transcended when the Yu Garden Charitable Association began to involve itself in activities on a broader social and national level. In the second half of the nineteenth century the feelings of collective belonging were focused mainly through artistic and commercial interests. But in the twentieth century a strong sense of nationalistic sentiments developed among artists. The need to get money to support the restoration and to preserve the best of native traditions was stated explicitly in the charter of this charitable association. Obviously, by the early twentieth century, Western imperialism in China had aroused nationalistic sentiments among the Chinese. Artists, in particular, must have recognised how deeply their profession was rooted in native traditions. Thus local cultural ties were transcended when artists in Shanghai took on the rhetoric of Chinese nationalism and called for the establishment of associations for mutual help and national survival.

Art Associations and Their Context
It is important to emphasise that the emergence of formal art organisations in Shanghai did not necessarily replace other informal networks. Pre-existing patterns of friendships or teacher-disciple relationships still persisted. And the traditional form

of elegant gathering did not totally disappear. We may cite the story of Ren Yi to explain the coexistence of old and new patterns in Shanghai. Ren Yi is said to have faked Ren Xiong's paintings when he was young. He was later discovered and caught by Ren Xiong who forgave him and even granted him the opportunity to learn painting from Ren Xun, Xiong's younger brother.[30] The novice Ren Yi studied with Ren Xun, and through his teacher's recommendation painted for patrons like Yao Kui (the son of Yao Xie) and Zhou Xian. In Suzhou, Ren Yi became acquainted with the famous Shanghai artist Hu Yuan, again through his teacher's introduction. When Ren Yi arrived in Shanghai, he received the support of two of the leading masters of the day – Hu Yuan and Zhang Xiong, both of whom were influential in Shanghai from the middle of the nineteenth century. Ren Yi was introduced by Hu Yuan to a local fan shop called the Studio of Antique Fragrance.[31] Moreover, he was said to have stayed for a while at the Pavilion of Flying Painting.[32] Ren Yi rapidly attained status in Shanghai, and seekers after his paintings were on his doorstep. Yet he continued to visit the Studio of Antique Fragrance regularly: many of his works done in the twelfth month of successive years bear inscriptions stating that they were painted in the mountain lodge of this fan shop.[33] In 1889 Ren Yi was invited to an elegant gathering held at a private estate, the Xu Garden, where he drew a painting for the garden owner Xu Di.[34] Some of Ren Yi's close friends were connected to the art associations in Shanghai. His friend and disciple Wu Changshuo was a prominent figure of the Shanghai Tijin Association, and his good friend Gao Yong would be one of the founders of the future Yu Garden Charitable Association.

In terms of their social and economic functions, art societies were very similar to the ordinary trade associations that existed at that time in Shanghai. It is not the intention here to compare art societies with other trade associations, but such economic practices in Shanghai are noteworthy. The painter Hu Yuan, for instance, had been employed by the Banking Industry Association (Qianye Gonghui).[35] Moreover, in the vicinity of Yu Garden, where artists used to gather, were numerous common-trade associations (*gongsuo*): Cotton *gongsuo*, Sugar, Candy and Imported Goods *gongsuo*, Southern and Northern Commodities *gongsuo*, Fresh Meat *gongsuo*, The Inner Garden Financial *gongsuo*, and so on.[36] The Yu Garden was no doubt the centre of commercial activities within the city walls of Shanghai. Equally significant was that the Yu Garden had been acquired by Shanghai transport merchants during the Qing dynasty.[37] Initially a private garden of the Pan family, it was purchased by merchants who then donated it to the City Temple. The Yu Garden became one of the public gardens of the City Temple – the social and religious centre of the Chinese city. Merchants refurbished the old pavilions and halls within the garden and transformed them into offices. Teahouses, antique stores and other recreational facilities were located there.[38] The concentration of fan shops and art associations in the Yu Garden thus suggests that artists were functioning like other merchant groups in a commercial environment.

Although art societies and commercial institutions were important components of the Shanghai art scene, one should not overstate the importance of these social and economic units in explaining the art of Shanghai. First, not all the artists who sold paintings in Shanghai were engaged in the activities of art associations. Second, there was no

evidence of an overarching occupational association which included under its umbrella all artistic activities in Shanghai. Collaborative works might be the products of artistic gatherings, yet these were not the only paintings available in the art market. Diversification was the economic strategy of artists in Shanghai, not the new direction put forward by and only by formal art associations. Contrary to what some scholars believe, art societies and commercial institutions had not led to the formation of a regional school despite the interactions of artists.[39] Nor had they shaped the styles and outlooks of paintings in Shanghai.[40]

COEXISTENCE, TENSION, AND
NEW CREATION: ON TRENDS IN PAINTING

Artists in Shanghai came from different regions, had inherited different artistic traditions, were working on varied subjects, and carrying on their own creative approaches to painting. The very diverse nature of the art community accounted for the coexistence of various trends in painting. Precisely what were these diverse trends? We may approach this by considering two major aspects: the heritage of different traditions and the various ways of transforming the traditions.

Landscapes

In landscape painting the persistence of the orthodox tradition was obvious. It emphasised the imitation of ancient models, a practice in art known as *fang*. The orthodox painter followed the ancients' methods or techniques, keeping the essentials of the prototypes, at the same time improvising upon them to transcend the formal aspects of painting.[41] Significantly, it was not formal likeness that the orthodox painter intended to achieve, but an originality that extended the life of the past. It was an art that brought life to previous art; it was artistic creativity that encompassed aspects of the self: one's mind or vision. Beginning with Dong Qichang (1555-1636) at Huating (Shanghai) in the late Ming, the orthodox movement spread quickly in the Qing dynasty to various regions throughout China. During the nineteenth century it made its way back to Shanghai when the orthodox successors from various regions travelled to and settled in the new metropolis. Hu Yuan was an important orthodox successor in Shanghai. Zhang Xiong, Tao Qi, Wu Tao and Yang Borun from Jiaxing; Wu Dacheng, Gu Yun and Lu Hui from Suzhou; as well as Ren Yu (1854-1901) from Xiaoshan who was also active in Suzhou, were other notable representatives.

By the late Qing the orthodox lineage had been extended, and past models for the successors also included earlier generations of the orthodox masters: Dong Qichang of the late Ming, the Four Wangs – Wang Shimin, Wang Jian, Wang Hui, Wang Yuanqi – of the early Qing, down to those who carried on the tradition into the nineteenth century, such as Wang Xuehao (1754-1832) and Dai Xi.

Besides upholding the lineage, the orthodox successors also followed the Wu School traditions of Suzhou, adding poetic sensitivity and peaceful intimacy to the endless mountains residing in the abstract exercise of brush and ink. This fusion with the Wu School heritage was a notable feature of the orthodox movement in the late Qing. Hu Yuan and Yang Borun, for instance, were both indebted to their teacher Shen Zhuo (19C) who studied the art of Wen Zhengming (1470-1559), the great Ming master of the Wu School, and made reference to Dong Qichang's composition and ink methods.[42]

The Wu School successor Wu Guxiang had Wen Zhengming and Wen's teacher Shen Zhou as his distant models, yet he also followed the styles of Dai Xi, his immediate model.[43]

The persistence of the orthodox and the Wu School traditions indicates that literati styles of landscape painting lingered on, even in the new metropolis of Shanghai. This was related to the fact that artists and collectors from the scholar-gentry class, who had been uprooted during the Taiping Rebellion, were then concentrated in Shanghai. So it is far from true that Shanghai's urban population only had a taste for popular and professional modes of painting which were allegedly less 'refined' than the literati styles.

Other painters like Ren Xiong, Zhao Zhiqian, Xugu and Pu Hua painted landscapes of originality, but these had not set the trends in the genre of landscape painting, regardless of their individual outstanding representations.

Flowers, Fruits, Birds and Animals

Continuity with the orthodox tradition was also evident in the flower genre. Yun Shouping was the much-admired model; artists including Zhu Xiong, Zhang Xiong, Wu Dacheng and Lu Hui had all been inspired by the way the orthodox master depicted the purity and lyricism of his subjects. Equally prominent was the Wu School heritage in flower depiction and, in particular, the influence of Chen Shun, Zhou Zhimian (active c1580-1610) and Wang Wu (1632-90). The result was a widening of the range of representation, giving rise to free, spontaneous and expressionist modes in portrayals of flowers and plants. Concerns for pace and movement in these late Qing works are shown not only in the expressive brushwork, but also in the colouring method, which takes advantage of the chance effects in the intermixing of colour washes and water blots. This method, owing to the Wu School heritage, differs from the subtle gradation of colour tonalities in Yun Shouping's paintings, and is evident in the works of Zhu Xiong, Zhang Xiong and so on.

Wang Li is mentioned in the *Haishang Molin* as a follower of Yun Shouping, yet his works differ from those of his exemplar.[44] He took on an emboldened approach with works characterised by bold images, emphatic brushstrokes, rich and brilliant colourings – a style that was widely accepted in Shanghai. The success of Wang Li could be interpreted as his ability to extend the visions of his orthodox predecessor. But it was also due to his indebtedness to his teacher Shen Rong (1794-1856) and to the Northern Song masters, from whom he learned his brilliant colouring methods.[45] Wang Li set off a new trend to be followed by at least two important artists in Shanghai: Zhu Cheng and Ren Yi. His popularity and renown by mid century were widespread.

The legacy of Yangzhou was carried into nineteenth-century Shanghai by individual artists in varied ways. Xugu from Yangzhou brought the region's painting traditions to late Qing Shanghai. His extremely simple, stunning images recall the works of Jin Nong (1687-1763), whereas his delightful renderings of birds and animals were indebted to Hua Yan (1682-1756), though he gave his works a cool sense of touch that underscored his Anhui inheritance. Zhu Cheng was another flower and bird painter who followed Hua Yan's mode of depiction in his later years. In addition, the influence of Li Shan (1686-1762), a Xinghua artist active in eighteenth-century Yangzhou, is evident in the flower paintings of Pu Hua, Qian Hui'an and Wu

Changshuo. These artists tended to suffuse swift, broad strokes with bold washes of ink or colours, and one may perhaps trace this trend of development back to Xu Wei (1521-93) of the late Ming, who painted in a free and spontaneous style characterised with uninhibited brushwork and wet ink.

More importantly, the legacy of Yangzhou should be viewed not only in terms of the indebtedness of individual artists to the so-called Eight Eccentrics of Yangzhou. It should also consider the prolonged influence of Shitao. As observed by James Cahill, the late works of Shitao done in Yangzhou before his death had exerted a tremendous impact on the later developments of the flower and plant genre. Certain aspects in the works of the late Qing artists confirm this heritage. The way the artists mixed colours and let them run together, the attempt to suffuse ink with colours, the juxtaposition of brushstrokes and colour washes to form an interlocking structure – all these had been explored in the works of Shitao.[46] To these the late Qing artists added all possible methods in the use of brush, ink and colours. Some adopted the brilliant and opaque colourings of the Northern Song tradition or had their colour washes bounded by ink outlines; others continued to explore the possibilities of blending colours with ink washes in order to bring out a wider range of hues. The effects were inexhaustible.

Coexisting were the *gongbi* styles of Ren Xiong, Ren Xun and Ren Yi. The term *gongbi* refers to a careful and meticulous manner of depiction by which colours are applied within the contours of forms delineated with fine brushwork. The Rens employed emphatic lines to define schematised forms. Their tendency to reduce forms to schematic and consciously exaggerated patterns was inspired by

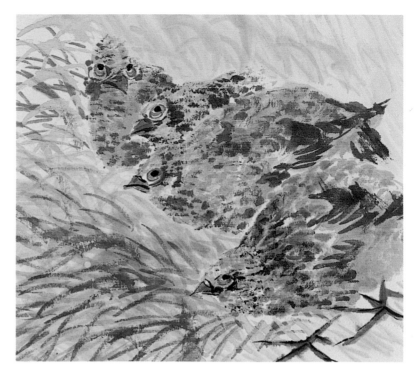

Detail from Quails *by Ren Yi in the* Album of Various Subjects (1886) *showing the fusing of brushstrokes and colours to form an interlocking structure.*

the folk tradition of woodblock prints. The Rens tended to use bright mineral pigments. This shows the popularity of the pleasing coloured styles of the Northern Song tradition in late Qing Shanghai.

Ren Xun and Ren Yi were also renowned for their spontaneous flower and bird depiction, and the latter gave a new direction in the genre by drawing inspiration from the art of Bada Shanren and of Wang Li. Ren Yi's paintings attain a sense of immediacy through his lively images, sweeping brushstrokes, and sensitive colour and ink washes. Full of vitality and intensity, his works had tremendous appeal in Shanghai.

Another major trend in the genre of flower and bird painting was the *jinshi* approach. Zhao Zhiqian and Wu Changshuo were prominent figures who projected the aesthetic qualities of ancient writings into their works. The calligraphy from which they drew inspiration was done on metal (*jin*) and stone (*shi*): inscriptions on ancient ritual bronzes, steles and tombs. It is to be noted that Chinese artists had always regarded painting as the extension of calligraphy. But in a climate of antiquarianism in the latter half of the Qing – due to new archaeological findings and to Evidential Research (scholastic studies based on empirical investigation of ancient texts) – metal and stone inscriptions came to attract the attention of artists. Creation of a sense of antiquity in painting based on epigraphy became the aesthetic vogue of the period.

One may ask what the artist could learn from ancient writings. The inscriptions on ancient bronzes or stone steles are written – or indeed engraved – with restraint and control. In every single stroke strength and force come through. Later calligraphers and painters could derive their brush technique from the ancient writings to create a majestic style that

shows considerable gravity and density. Moreover, ancient scripts offer a rich set of graphic type-forms for artists to study. Because every ancient Chinese character is itself a rigid form combining the written areas and the open spaces, the charming structures of ancient scripts could instruct artists on methods of composition. Besides, ancient writings exhibit an antique grace and elegance, an aesthetic quality highly prized by the artist.

Zhao Zhiqian and Wu Changshuo developed their distinctive brushwork and compositions through their studies of ancient writings. Wu further absorbed the expressionist modes of Xu Wei, Bada Shanren and Li Shan into his *jinshi* style, resulting in works with considerable force and vigour. The paintings of these *jinshi* masters combine the linear rhythms of robust brushwork with the glowing colours of flowers and fruits. The vigour and force that penetrate their brushwork are controlled in a subtle way; the pleasing colours are subdued by the intensity of ink. Using the *jinshi* style, they attained a balance of profound dignity and decorative beauty in late Qing painting.

Figures

In figure painting, artists like Fei Yigeng (19C), Hu Xigui (1839-83) and Wu Guxiang depicted beautiful ladies in styles strongly recalling those of Gai Qi (1744-1829) and of Fei Danxu (1801-50), two renowned earlier painters of the genre in Shanghai. Their images of beauties may be called classical: a relatively large face, the eyes to suggest interpersonal interaction, facial expression and gesture to convey the gracefulness of genteel women. The embodiment of the idea of woman was in her face, her gesture and her activity.[47] So there is no intention to feature the physical body, although the flowing

garment and the sloping shoulders might accentuate the sensuous charm of the lady.

The aforementioned *gongbi* styles of Ren Xiong, Ren Xun and Ren Yi formed another prominent trend in figure painting. The Rens followed Chen Hongshou (1598-1652), whose idiosyncratic style of figural depiction is well known. The peculiarity of Chen's figures as well as his 'iron wire' outlines – which were believed to have associations with the ancient manner of depiction – denote his archaic style in figure painting. The Rens worked in a similar mode and were able to develop their own linear brushwork: Ren Xiong tended to use angular contours; Ren Xun accentuated the stress of his brush at the beginning and ending of a stroke; Ren Yi preferred his wavering and fluttering lines. Their linear brushstrokes are repeated rhythmically to give an archaising schematic outlook. When applied to subjects like immortals, popular deities, or historical figures, the archaising and mystifying effect was remarkable.

As mentioned above, the Rens' linear and schematic styles bore resemblance to woodcut designs, which is not surprising as these artists all came from Xiaoshan, Zhejiang province. Both Ren Xiong and Ren Xun were natives of the region; Ren Yi was a native of Shanyin, but his family had moved to Xiaoshan. Ren Xiong had co-operated with Cai Zhao, a Xiaoshan engraver, in the publication of the *Immortal Wine Cards* (cards with immortals' images used in games when drinking wine). Another major undertaking of Ren Xiong in woodblock prints – *The Past Worthies of the Zhejiang Region* – also relates to the artist's regional identity. Evidently, the Xiaoshan artists had contributed to introducing the linear and schematic styles to Shanghai. But this trend appeared across urban centres in other provinces, like Suzhou in Jiangsu

and Huizhou in Anhui. We may see the development in a wider context of painters seeking inspiration from folk traditions or producing works for translation into prints during the Qing period. Besides the Rens, Sha Fu (1831-1906) from Suzhou and Qian Hui'an from Baoshan also produced works showing close stylistic parallels with prints or New Year drawings (*nianhua*).

All the trends mentioned above denote artistic changes based on the heritage of native traditions. Another trend – the adoption of Western techniques – commands special attention. Painters borrowed Western representational techniques to renew their native traditions. The result was a hybrid of native and foreign elements in painting.

The Western Influence

The Western influence is evident in paintings of various subjects: figure, portrait and landscape. It is especially prominent in figure and portrait paintings, as the vividly realistic style of the West best suits the concern for formal likeness in these genres. Painters involved in this trend included Ren Xiong and Ren Yi. The new style was characterised by contrasts of light and shade to bring out the concavities and convexities of forms, applied most readily to facial rendition. Ren Yi gave equal concern to the substance of the physical body underneath a robe. His relatively successful application of the Western techniques to Chinese figure painting could be attributed to two factors: first, his drawing from life as the basis for learning traditional Chinese portraiture; and second, his practice of sketching at the Tushanwan Library, Shanghai, where he learned Western techniques. Wu Jiayou was another artist who painted his subjects from life. Although he derived his images of contemporary Shanghai ladies

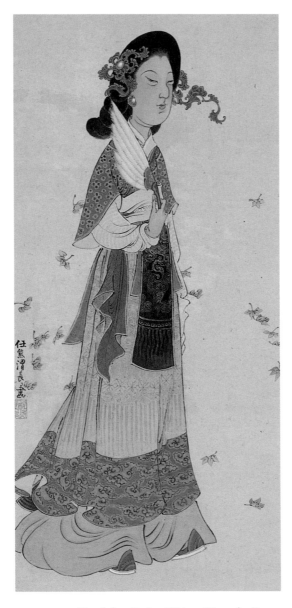

Detail from Lady of River Xiang *by Ren Xiong showing the combination of archaism and ornamentation in Chinese painting.*

from the elegant prototypes of Gai Qi and of Fei Danxu, he was also concerned with the solidity of human forms. The vital physicality of his figures underscores the Western influence.

The landscape painter Wu Qingyun had been to Japan where he was exposed to Western art. His works are characterised by a subtle play of light and colour, achieving an effect similar to Western chiaroscuro.

We have seen sufficient examples confirming the Western impact on Chinese paintings in late Qing Shanghai. But it is notable that the infiltration of the Western pictorial elements was partial and selective. The Chinese artist was steeped in native traditions, and knowledge of Western representational technique simply meant that he had at his disposal a wider repertory of styles from which he might select.

In general, heterogeneity characterised the Shanghai art scene. A vast variety of subject matters was painted: landscape, flowers, fruits, animals, portraits, beautiful ladies, immortals and popular deities. A diversity of styles was also pursued: simple, detailed, spontaneous, meticulous, expressive, descriptive, wild, restrained, monochrome, colourful, classical or vernacular. Because these styles were derived from various painting traditions – such as scholar-amateur as opposed to professional; elitist as opposed to popular; Chinese as opposed to Western – their coexistence implied that tensions among them were inevitable. Creative tensions might occur when opposing styles were combined in a single work, opening a new artistic direction. Examples include the juxtaposition of the *jinshi* style with bright colouring, the fusing of the pleasing *gongbi* style with the archaising schematic mode, and the mixture of Chinese and Western elements in painting.

Coexistence and tension – which typify the situation in art – could be understood in the broader context of Shanghai culture which displays similar characteristics. This does not imply that painting is a mere reflection of other developments in society. Painting is itself a primary cultural document, and artists in late Qing Shanghai responded to the demands of cultural changes in many different ways. Some revived ancient modes of painting and writing, others borrowed Western techniques, or might juxtapose old and new methods in unprecedented ways. The new creations – hybrid products of old and new, native and Western – not only allowed for transformations of traditions, but also gave artists a sense of cultural continuity in a period of accelerated political and social changes.

It is commonly believed that the successful artists were able to satisfy both 'refined' and 'vulgar' tastes. This may be interpreted as an attempt by artists to reconcile the tensions between opposite demands in painting. Nevertheless, artists were probably also caught in the ambivalence that pervaded the new metropolis. Ambivalence was itself a broader cultural phenomenon as people in Shanghai lived between different cultures and systems. For the Chinese artist who relied on past traditions, feelings of uncertainty intensified as he witnessed the many changes that troubled his age. This may be indicated in the following lines inscribed by Ren Xiong on his self-portrait, now in the Palace Museum in Beijing:

> In the confusion,
> what is there to hold on to and rely on?
> ...
> I already am completely without any idea.
> In the flash of a glance,
> all I see is a boundless void.[48]

Ren Yi, one of the most successful artists in Shanghai, employed Western techniques in his figure paintings, but his own words are telling:

> I have often lamented that today's officials seek after barbarians' culture to transform China and alter her ways. Some have gone so far as to promote such ideas as democracy and egalitarianism. It is to take our esteemed moral principles and let the flippant youths have a field day... In China, the moral obligation in relationships between lord and subject, between father and son, between husband and wife, between brothers, and between friends can be traced back through Yao and Shun and the three dynasties [Xia, Shang, Zhou]. Having been so taught and instructed, it has become deeply embedded [in our minds]. How the world has changed, so much and daily, to such a degree of ferment![49]

It is typically ironic that Ren Yi, while manifesting in painting his willingness to depart from old conventions, was at the same time rejecting other new ideas from the West. This indicates the ambivalence one might experience in daily life at the close of the Qing empire and how a person's views may change according to context. Art in Shanghai was embedded in a world in turmoil.

SHANGHAI SCHOOL OF PAINTING

The term *Haipai* or Shanghai School is used in art history to categorise paintings of late nineteenth-century Shanghai. Initially a term of contempt used to ridicule the concern for visual appeal in Shanghai's theatrical performances, it was applied to literature and painting as well, carrying similar negative connotations. Such criticisms were an extension of a biased perception that mercantile culture lacked subtlety, refinement and sophistication. Gradually there was a dissipation of the negative views in relation to the term, and Shanghai School became a

convenient categorising label. Painters working in different styles were subsequently included as members of the school.[50]

But was there really a regional school of painting in Shanghai during the late Qing period? Since many artists were immigrants coming from different regions and working in different styles, there was no common denominator relating them to a single regional school. Some artists might derive their styles from individual masters – such as Ren Xiong from the elder Rens; Zhu Cheng and Ren Yi from Wang Li – but these only represent the transmission or permutation of certain styles of painting in Shanghai. There was no single trend that dominated the art scene. Coexistence of different trends was the reality.

In this respect, the use of the term Shanghai School is highly problematic. But perhaps we can interpret this term from a new perspective by taking into consideration the cultural characteristics of Shanghai itself.

First, the term Shanghai School suggests a geographic parameter. The role of Shanghai as a focal point of artistic developments in the late Qing period cannot be denied. In Shanghai there was an enormous concentration of human and material resources. Moreover, commercialisation of Chinese painting in this period was not unrelated to the corporate nature and enterprising spirit of the city. Second, social changes took place at an accelerated rate in this new metropolis – the tensions between old and new, native and foreign – intensified in Shanghai because of its position as a treaty port. Third, the coexistence of different artistic styles and traditions in Shanghai was sustained by a high level of cultural tolerance on the part of the urban population. The inclusiveness of the term points directly to the hybrid nature of Shanghai culture.

Anita Chung
Curator of Chinese Art
National Museums of Scotland

NOTES

1 *Tieluo* (literally, pasted and removable) paintings were painted by court artists who worked within the imperial academy. Some of them are still preserved in the Forbidden City, Beijing. See Nie Chongzheng, 'Architectural Decoration in the Forbidden City: *Trompe-l'oeil* Murals in the Lodge of Retiring from Hard Work', *Orientations*, vol. 26 (July/August 1995), 51-5.

2 See Linda Cooke Johnson, *Shanghai: From Market Town to Treaty Port, 1074-1858* (Stanford, 1995), 8-14.

3 *Ibid.,* 156-7.

4 On the trade and commerce in Shanghai prior to the Opium War, see *Ibid.,* 161-5.

5 On how native-place associations organised the habits of everyday life of the sojourners in Shanghai, see Bryna Goodman, *Native Place, City, and Nation: Regional Networks and Identities in Shanghai, 1853-1937* (Berkeley, Los Angeles and London, 1995), 14-29.

6 *Ibid.,* 19.

7 Johnson, *Shanghai,* 122.

8 Goodman, *Native Place,* 121-5. Also see Johnson, *Shanghai,* 145.

9 Johnson, *Shanghai,* 214.

10 See Betty Peh-T'i Wei, *Shanghai: Crucible of Modern China* (Hong Kong, Oxford and New York, 1987), 66-7.

11 Goodman, *Native Place,* 146.

12 Frederic Wakeman, Jr and Wen-hsin Yeh, eds., *Shanghai Sojourners* (Berkeley, 1992), 13.

13 See Goodman, *Native Place,* 158.

14 Hu Yuan was a Huating native, but he was regarded as a 'sojourner' in Yang Yi, *Haishang Molin* (preface dated 1919; reprint, Taipei, 1988), entry 419. Hu Yuan was in Shanghai in the winter of 1855, when he wrote the preface to the *Yingruan Zazhi* by Wang Tao.

15 See Claudia Brown and Ju-hsi Chou, *Transcending Turmoil: Painting at the Close of China's Empire 1796-1911* (Phoenix, 1992), 138, 336, note 131.

16 Yang, *Haishang Molin,* entry 431.

17 Zhang Mingke, *Hansongge Tanyi Suolu* (preface dated 1908; reprint, Shanghai, 1988), 150.

18 The inscription is recorded in full after the entry on Wu Zonglin. See Yang, *Haishang Molin,* entry 340.

19 Yang, *Haishang Molin,* entry 340.

20 *Ibid.,* entry 438.

21 See Gao Yong's preface to the *Haishang Molin,* 1a-b.

22 Yang, *Haishang Molin,* entry 389.

23 *Ibid.,* entry 521.

24 Gao Yong's preface to the *Haishang Molin,* 1a.

25 See Huang Ke, 'Qingmo Shanghai jinshi shuhuajia de jieshe huodong', *Duoyun,* no. 12 (January 1987), 143.

26 James Cahill, *The Painter's Practice: How Artists Lived and Worked in Traditional China* (New York, 1994), 49.

27 *Ibid.,* 49.

28 *Ibid.*, 144.

29 Yang, *Haishang Molin*, entry 438.

30 See Xu Beihong's account in *Ren Bonian Huaji* (Singapore, n.d.), 1-2. Also see Ding Xiyuan, ed., *Ren Bonian* (Shanghai, 1989), 9-10, and Brown and Chou, *Transcending Turmoil*, 178-9.

31 Fang Ruo, *Haishang Huayu*, quoted in Ding, *Ren Bonian*, 25.

32 Huang Ke, 'Qingmo Shanghai', 143.

33 Ding, *Ren Bonian*, 65, 73.

34 *Ibid.*, 95.

35 Fang Ruo, *Haishang Huayu*, quoted in Ding, *Ren Bonian*, 25.

36 See Wang Tao, *Yingruan Zazhi* (preface dated 1871; reprint, Shanghai, 1989), 38. Also see Johnson, *Shanghai*, 148.

37 Johnson, *Shanghai*, 99.

38 Wang, *Yingruan Zazhi*, 37.

39 See the argument in Huang Ke, 'Qingmo Shanghai', 147.

40 This view is put forward by Shan Guolin in an unpublished paper 'Shilun Haipai huihua de chuantong yuanyuan'.

41 Ju-hsi Chou, 'In Defense of Qing Orthodoxy', in *The Jade Studio: Masterpieces of Ming and Qing Painting and Calligraphy from the Wong Nan-p'ing Collection* (Connecticut, 1994), 38.

42 Yang, *Haishang Molin*, entry 331.

43 *Ibid.*, entry 518.

44 *Ibid.*, entry 384.

45 Jiang Baolin, *Molin Jinhua*, in Zhou Junfu, ed., *Qingdai Zhuanji Congkan*, 205 vols. (Taipei, 1985), 73:555.

46 James Cahill, 'The Shanghai School in Later Chinese Painting', in Mayching Kao, ed., *Twentieth-Century Chinese Painting* (Hong Kong, Oxford and New York, 1988), 55.

47 See John Hay, 'The Body Invisible in Chinese Art?' in Angela Zito and Tani E. Barlow, eds., *Body, Subject, and Power in China* (Chicago, 1994), 52.

48 Translated into English by Richard Vinograd. For the full inscription in English, see Richard Vinograd, *Boundaries of the Self, Chinese Portraits, 1600-1900* (Cambridge, 1992), 129.

49 Cited in Ding, *Ren Bonian*, 47. English translation by Ju-hsi Chou, *Transcending Turmoil*, 181-2.

50 See Brown and Chou, *Transcending Turmoil*, 102-3.

ARTISTS AND THEIR WORKS

ZHANG XIONG
1803–86

Zhang Xiong was a venerated figure in the Shanghai art community during the second half of the nineteenth century. Writers of his time, like Wang Tao, Huang Xiexun and Ge Yuanxu, all mention his name when listing major masters in Shanghai. Zhang had a group of prominent students, and among others, Zhou Yong (19C) and Zhu Cheng became famous artists. Another disciple Chao Xun (1852-1917) republished the *Mustard Seed Garden Painting Manual* (1888 edition) under his teacher's influence.

Zhang came from Jiaxing, Zhejiang province, specialising in landscape and flower and bird paintings. He owned a collection of ancient vessels and works of art in his studio, the Silver Vine Blossom Lodge. During his middle years, his wife died, and he never remarried. He settled in Shanghai after the Taiping rebels had occupied his hometown.

Zhang took an active interest in calligraphy, painting, poetry and opera. In calligraphy he followed the style of Huang Tingjian (1045-1105) and occasionally wrote the clerical script in a simple and archaistic mode. In painting he upheld the orthodox tradition and sought inspiration from the Four Wangs (Wang Shimin, Wang Jian, Wang Hui, Wang Yuanqi), Yun Shouping and Wu Li. As noted by the art critic Yang Yi, Zhang's floral depictions also register influence from the Wu School artist Wang Wu.

The floral depiction in the *Autumn Flowers, Plants, and Insects,* falls within the 'boneless' tradition of Xu Chongsi (11C). Zhang uses the 'boneless' technique whereby the flowers are portrayed without any linear definition. The opaque colouring of the golden plant as well as the curling leaves strongly recall the mode of Yun Shouping. One can also see the impact of Wang Wu in the depiction of the other flowering plants. The shifting tones of colour wash create a vibrant effect, which differs from the heavy layering of colours for the golden plant.

Flowers, an album of twelve leaves, confirms Yang Yi's observation that Zhang Xiong's flowers are as archaic and delicate as those of Wang Wu. The expressive mode of floral depiction, a style modelled after Wang Wu, is here in contrast to the meticulous depiction of the animals, birds and insects. There is no doubt that Zhang succeeds in capturing a sense of life as well as the delicate charm of his subjects.

Autumn Flowers, Plants, and Insects
1877

Hanging scroll, ink and colour on paper
93.5 x 46.7 cm
With artist's inscription, signature, and 2
seals; 1 collector's seal

Gift of Qian Jingtang

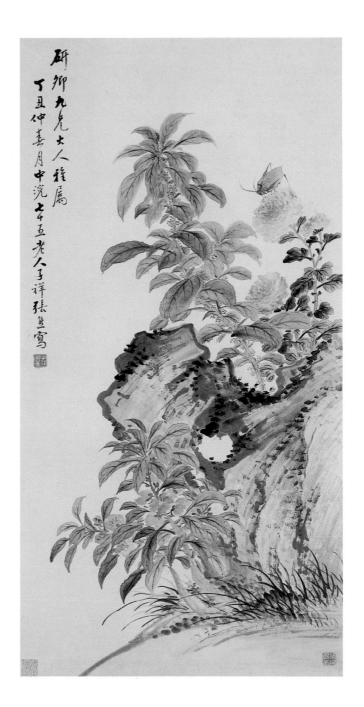

ZHANG XIONG
1803-86

Flowers
Not dated

Album of twelve leaves, ink and colour
on paper
Each leaf 31.8 x 48 cm
With artist's inscriptions, signatures, and
14 seals

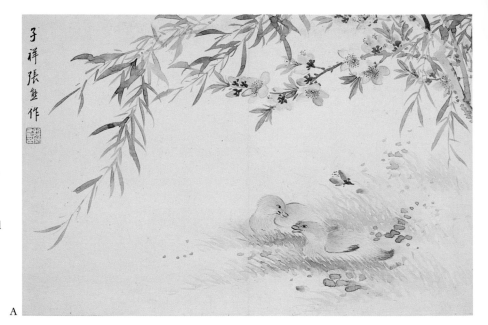

A

E

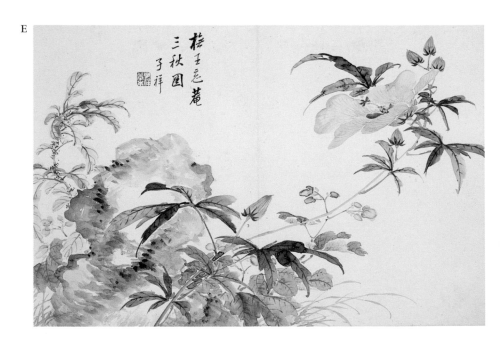

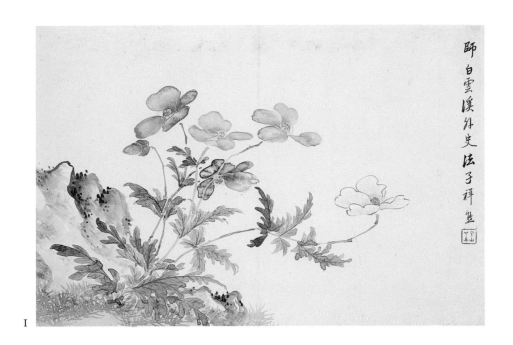

師白雲溪外史法子祥寫

I

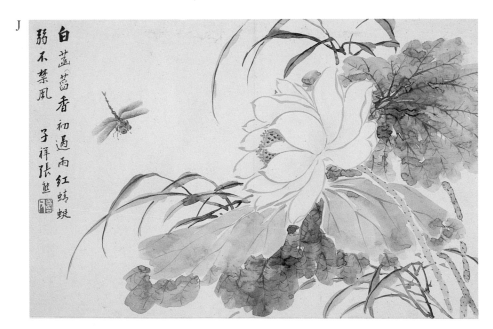

白藕香初過雨紅蜻蜓
白藍弱不禁風 子祥張熊

J

51

ZHU XIONG
1801-64

Chinese art historians tend to associate Zhu Xiong with both Zhang Xiong and Ren Xiong and call them the 'Three Xiongs' (literally, the three bears) of Shanghai. This is out of convenience – since they are united by name – but does not have much historical significance as regards their activities in Shanghai. Perhaps the pairing of Zhang and Zhu reminds us of their common place of origin in Jiaxing and of their teacher-disciple relationship.

Zhu Xiong was a versatile artist who immersed himself in painting, calligraphy, seal carving, pottery and connoisseurship. Of all the ancient vessels he appreciated, he was particularly fond of Yixing wares. He had been to Jingdezhen to make his ceramic painting accoutrements and to Yixing to create his earthenware. His circle of friends included Zhang Tingji (1768-1848), Wen Ding (1766-1852) and Yin Shubo (1769-1847) – all were interested in calligraphy, *jinshi*, seal or bamboo carving. He also befriended Li Xiuyi (d1811), the author of the *Xiao Penglai Ge Huajian*.

Zhu was one of the senior artists in Shanghai during the second half of the nineteenth century. He and his younger brother, Zhu Cheng, were both the founding members of the Duckweed Society. As a painter, he excelled in the renditions of flowers, bamboo and rocks. He was praised for his originality in painting and that his individual style found no similarity with those of his contemporaries in Jiaxing. Zhu admired Zhang Xiong's paintings so much that he regarded Zhang as his mentor, despite the fact that he was two years Zhang's senior. When asked why his works differed from his teacher's, his reply was that he presented the ideas rather than the formal likeness.

The album *Flowers*, dated 1857, exhibits the effortless ease and spontaneity of Zhu's flower paintings. Like Zhang Xiong, Zhu is concerned with capturing the inner essence of the floral subjects. Whereas Zhang has precise control of the placement of every line or form so that the motifs echo each other to evoke lyrical grace, Zhu attains a freedom in his arrangement of subjects and manages to present an impressionistic view of his lively images. Swift brushstrokes and the shifting tones of colours enhance the quality of liveliness in Zhu's paintings.

Flowers
1857

Album of ten leaves, ink and colour on paper
Each leaf 27.9 x 31.3 cm
With artist's inscriptions, signatures, and 11 seals

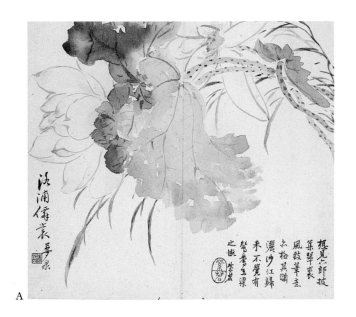

A

想見六郎披
策翠千裘
風致華意
六柯其萬
灑沙江婦
米不覺有
鴛鴦玉梁
之畫紫岩

涇浦傅巖
要畧

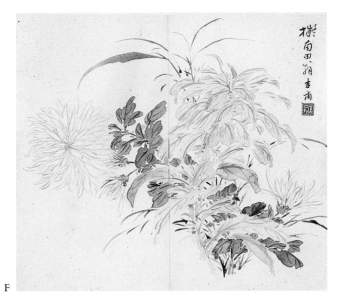

F

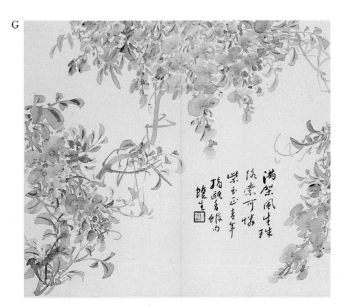

G

满架风生珠
佩索可懂
紫玉正青年
摘頭有眼內
塗生

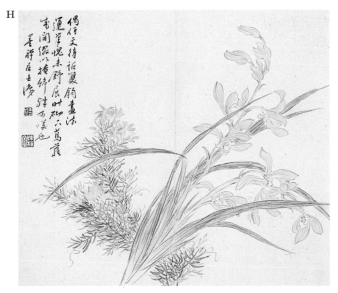

H

偶倚文待詔夏
銷畫法
運筆悦末階展
时砌六篇靈
書閱紙隆補飾
鉅万美此
墨禅居士澐

WANG LI
1813-79

As an eminent figure in Shanghai, Wang Li enjoyed equal prominence with Zhang Xiong, Hu Yuan and the Three Rens (Ren Xiong, Ren Xun and Ren Yi). Indeed, he ranks first in the list of famous artists mentioned by Wang Tao in the *Yingruan Zazhi*, a book of accounts of Shanghai written after 1853 and published in 1874. Wang Li was a member of the Duckweed Society, and collaborated with Qian Hui'an and Bao Dong in depicting the gathering of the twenty-four members in 1864. As Wang's reputation rose rapidly in Shanghai, he became the exemplar of success. Artists like Zhu Cheng and Ren Yi followed his style.

Wang Li came from Wujiang, Jiangsu province. He studied painting with Shen Rong, from whom he derived his brilliantly coloured style in floral depiction. He created a personal style characterised by forceful brushwork and bold images, resulting in works with a strong visual effect. In the *Chrysanthemums and Duck* of 1864, a few stalks of flowers, a swimming duck and some long grass dominate the composition. The sharp, spiky grass is rendered with insistent force while the chrysanthemums are painted with elegant precision. Although the dark image of the duck heightens the sense of immediacy,

the colouring is executed in a refined manner recalling the Northern Song tradition.

Peonies and Birds, a late work dated 1877, typifies Wang Li's bold approach to painting. The deliberate composition, the swift brush movement, the brilliant colouring and the overall visual appeal – all these give the work a kind of decorative beauty favoured by the wide audience in Shanghai.

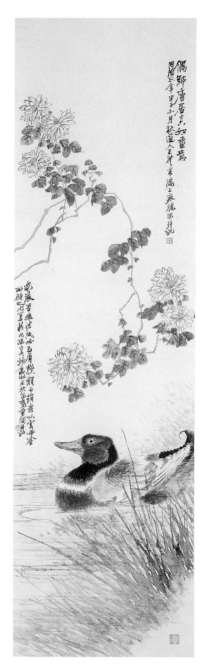

Chrysanthemums and Duck
1864

Hanging scroll, ink and colour on
paper
128.3 x 36.5 cm
With artist's 2 inscriptions, signatures,
and 3 seals

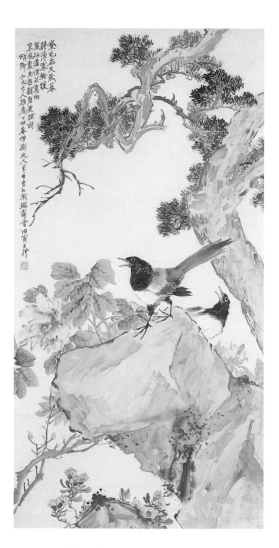

Peonies and Birds
1877

Hanging scroll, ink and colour on paper
127.8 x 63.7 cm
With artist's inscription, signature, and 1
seal; 1 collector's seal

Gift of Qian Jingtang

TAO QI
1814-65

Tao Qi was a landscape painter of orthodox lineage. Coming from Jiaxing, he participated in the artistic gatherings of the Duckweed Society and lodged at the mansion of Pan Chengzhan in Shanghai. Pan was an art collector, calligrapher and painter who often discussed the principles of painting with Tao. Later Pan became a district magistrate in Zhejiang. The case of Tao Qi and his patron-friend shows that the orthodox manner of landscape painting continued to be favoured by the social elite in Shanghai.

In the *Xiao Penglai Ge Huajian* the critic Li Xiuyi remarks on Tao Qi's paintings:

> The landscapes he painted are dense, yet they evoke a bland flavour and give a soothing effect. He has opened up a new path without following in others' footsteps. Recently, I saw one of his fan paintings done in the brush manner of the Yuan masters. Its style is approaching the archaic.

Tao eventually evolved a style based on those of the Yuan and Ming masters. He upheld the orthodox tradition, and in his later years he mostly painted in the style of Wang Hui of the early Qing period. It is said that every tree or rock of Tao Qi resembles those of Wang Hui.

Landscape, dated 1864, is among Tao's late works. His inscription states that it is done after Huang Gongwang (1269-1354), based on the brush idioms of Wang Yuanqi and of Wang Hui. More importantly, it reveals his faith in the orthodoxy. Believing that the orthodox tradition still persists, Tao remarks on the degradation of works done by later followers and even criticises his own brushwork for weakness, despite his conscientious effort to seek a spiritual kinship to Huang Gongwang. He says that he owns famous works by the Yuan masters.

Landscape
1864

Hanging scroll, ink and light colour on paper
106.8 x 44.5 cm
With artist's inscription, signature, and 2 seals; 1 collector's seal

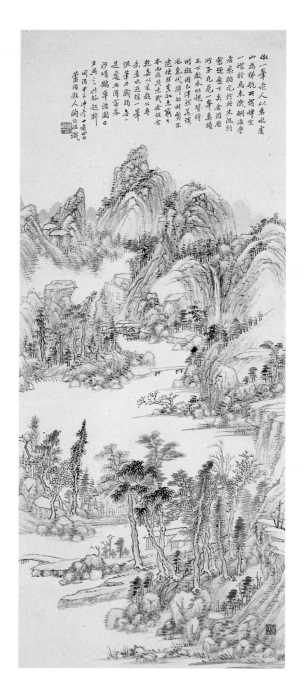

HU YUAN
1823-86

Although Hu Yuan was a native of Huating (Shanghai), he was regarded as an immigrant in the *Haishang Molin*. He was one of the most famous artists in Shanghai. His name is included in almost all contemporary textual accounts of the Shanghai art scene. For example, Zhang Mingke believed that Hu Yuan and Ren Yi were the two most prominent artists in Shanghai. Other contemporary writers like Wang Tao, Ge Yuanxu, Huang Xiexun also spoke of him as a key figure. Yang Yi noted that his paintings were admired by famous Jiangsu and Zhejiang artists, who believed one could not see much better works than Hu Yuan's in the last 300 years. Other incidents that marked his prestige include his being employed to paint for the Banking Industry Association as well as his popularity in Japan. As noted by Wang Tao, 'a piece of [Hu's painting] is worth a city in Japan.' With such a reputation, Hu assumed artistic leadership in Shanghai.

Hu Yuan had been active in Shanghai in 1855 when he wrote the preface to the *Yingruan Zazhi* by Wang Tao. He first resided in the mansion of Mao Shuzheng, a connoisseur and collector of art in Shanghai. Later he bought a mansion in the eastern part of the city and named it the Hermit Crane Studio. Xugu was one of his usual guests. One day, Hu asked for a portrait painting from Xugu (who normally refused to give out a painting unless the recipient was his confidant). Xugu painted Hu a portrait, but shortly afterwards Hu died.

Although Hu Yuan was proficient in both calligraphy and painting, he gained his reputation as a specialist in landscape and flower painting. He studied painting with Shen Zhuo who was indebted to Wen Zhengming, Dong Qichang, Xi Gang and Wang Xuehao in landscape painting. Thus Hu Yuan's landscapes can be understood in terms of the stylistic origins of his teacher, and in this respect the influence of Wang Xuehao was particularly prominent in the development of Hu's styles. This places Hu as a follower of the orthodox school in landscape painting. As regards flower painting, Hu followed the styles of such Wu School artists as Shen Zhou and Chen Shun.

The contemporary writer Huang Xiexun appraised the Shanghai art scene:

> Good artists may not be famous, and famous artists may not be good. In Shanghai, a complementary remark by one person is immediately echoed by many other people. Finally, there is only vulgarity, not an air of refinement.

But whether the audience in Shanghai was sophisticated or not, Hu truly deserved a high reputation as a landscape painter who attained freshness and spontaneity in painting.

In *Cloudy Mountains* of 1875, Hu uses broad, lively strokes, and wet ink wash to present pure and peaceful views of landscape. The inscription credits Gao Kegong (1248-1310) as the source of inspiration, who himself followed the 'Mi dots', the brush idioms of Mi Fu (1051-1107). Hu mixes the 'Mi dots' with his sweeping brushstrokes and suffuses them with soft ink wash to heighten the sculptural effect of the mountains. A spectrum of tonal values accents the play of light on the cloud-filled ambience. Despite the simplicity of the composition, Hu's stylistic debt to the orthodox school is readily apparent in his solid structuring of architectonic forms, such as the boulders along the shore in the foreground or the cloud-enshrouded hills in the middle ground. On the two sides of the painting are colophons by Pu Hua and by Wu Changshuo, both dated 1893.

When depicting floral subjects, Hu adopts a different approach. In *Fragrance over the Calamus Pond*, there is a deliberate control of the speed and the direction of his brush movement to produce steady and weighty strokes. Every stroke is infused with strength, and the dark ink tones add to the solemnity of the painting. The apparent clumsiness in

execution illustrates the aesthetic view that technical virtuosity was not the highest state of art.

Cloudy Mountains
1875

Hanging scroll, ink on satin
157.8 x 41 cm
With artist's inscription, signature, and 2 seals; colophons and seals of Pu Hua (1832–1911) and Wu Changshuo (1844–1927); 1 collector's seal
Gift of Qian Jingtang

right
Fragrance over the Calamus Pond
Not dated

Hanging scroll, ink and colour on paper
178.9 x 47.5 cm
With artist's inscription, signature, and 1 seal; 2 collectors' seals

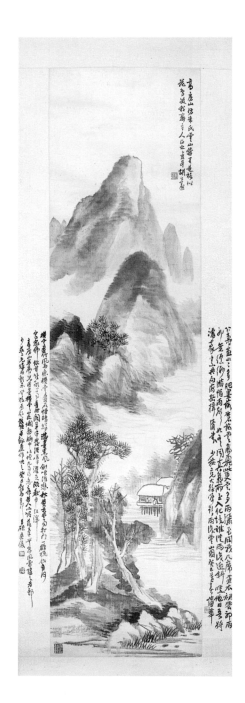

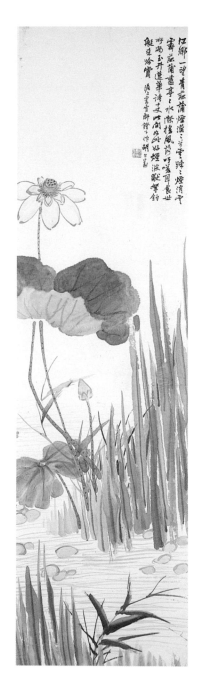

ZHOU XIAN
1820-75

The scholar-official Zhou Xian was best known as a patron-friend of the famous artist Ren Xiong, but he was also a painter and a member of the Duckweed Society.

Zhou Xian was a native of Jiaxing in Zhejiang. Because of the hereditary position held by his ancestors in the military service, his family had moved away from his hometown. As a military official, Zhou was based in various places. He was in Hangzhou in 1848 when he first met Ren Xiong. Then, in the early 1850s, Zhou travelled extensively, mainly to Suzhou, Hunan and Hubei. In 1853 Zhou was in Shanghai where he led a troop to suppress the riot led by Zhou Lichun of Jiading. After the military success, he was granted the honour of wearing the Blue Feather (the honour of an imperial bodyguard). However, during the early years of the Tongzhi era (1862-74), while serving as the district magistrate at Xinyang, Zhou was dismissed from office after an argument with a high official.

Zhou was an important patron of art before the decline of his fortunes. He owned a collection of paintings in his studio, the Thatched Cottage of Lake Fan in Hangzhou and generously allowed Ren Xiong to stay there for three years to study works of the ancient masters. He planned to construct a new residence near Lake Fan in his hometown where he would spend his retirement writing and attending to his mother. To realise this vision, he requested painters to depict the planned estate and scholars to compose poems. It seemed that his dream could not be realised with the decline of his fortune. As noted by Zhang Mingke, Zhou resided temporarily in Suzhou after the dismissal from office, selling paintings to support himself. This account suggests a drastic change of Zhou from a patron to a professional painter. However, Zhou continued to play a patron's role and even

extended his support to Ren Yi, his friend's follower. The portrait of Zhou Xian at forty-six *sui*, dated 1867, was done by Ren Yi in Hangzhou.

As a painter Zhou Xian worked in a manner close to Ren Xiong's, but he was able to transform Ren's methods into his own. Instead of using the angular brushwork of Ren, he tended to use round brushstrokes that are thick and weighty. His works are highly praised by art critics. Zhang Mingke comments on the richness and intensity of his flowers as well as the strength and elegance of his brushwork. He believed that no flower painter could rival Zhou in his time. Yang Yi also comments on his robust and awkward brushwork which gives his works an aura of antique refinement.

His achievement in flower painting is exhibited in *A Hundred Flowers* of 1867. According to the artist's inscription, he lived a humble and secluded life in Hangzhou after leaving office. Inspired by a long handscroll of flowers by Sun Kehong (1533–1611), he painted this scroll at leisure, adding one or two blossoms every day, without limiting himself to one model. It took him months to complete this painting.

A Hundred Flowers
1867

Handscroll, ink and colour on paper
30.8 x 1213.3 cm
With artist's inscription, signature, and 3 seals; frontispiece by Yang Yisun (1812–81); 9 colophons by Pan Zunqi (1808–92), Shen Jingcheng (19C), Jin Lan (b1841), Wu Changshuo (1844–1927), etc

Gift of Shen Tongyue and his family

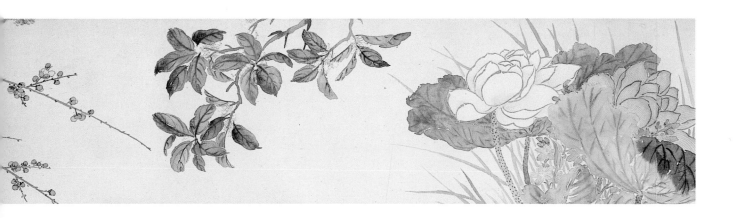

Ren Xiong
1823-51

Ren Xiong once painted a self-portrait, now in the Palace Museum, which shows a lifesize image of himself with the face expressing anger and the torso revealing physical strength. The clothes are rendered by Ren's typical angular strokes, which convey tremendous force and power. Nevertheless, what is suggested by the image – intense emotion and strength – is contrary to the written message of the inscription that states the feeling of loss and uncertainty of the artist who sees only 'a boundless void' in his world. Such ambiguity makes this painting an interesting work for interpretative studies. Although it may manifest the typical anxiety of an ordinary man in a period of rapid political and social change, this very act of representing the self reveals that Ren Xiong was an unusual artist in his time. He died in 1857 at the age of only thirty-five.

Ren Xiong was a versatile artist who immersed himself in a wide range of interests: painting, poetry, music, martial arts, archery and riding. Born in Xiaoshan, he was also active in major cities in Zhejiang and Jiangsu provinces. According to the *Haishang Molin*, he travelled occasionally to Shanghai. Although seekers of his paintings came one after another, he did not stay there long.

He met Zhou Xian in Hangzhou in 1848 and spent three years studying the works of the ancient masters in Zhou's studio. Later he met the famous poet Yao Xie in Ningbo and stayed in Yao's retreat for one year, painting a series of albums to illustrate Yao's poems.

Lady of River Xiang exemplifies Ren's idiosyncratic manner of figural depiction, inherited from the late Ming artist Chen Hongshou. The peculiar appearance and the linear method were believed to be the characteristic features of the ancient mode of figural depiction, by means of which artists of later periods could create a sense of antiquity in painting. However, when Ren employs bright colours and exquisite patterns the fill the outlined forms, descriptive complexity substitutes for archaic simplicity. The result is a combination of archaism and ornamentation as well as a tension between two opposite trends in Chinese painting.

Ren was capable of producing a range of styles and subjects. He adopts a free, spontaneous style when depicting the *Cat Sleeping in the Shade of the Banana Tree*. The fluent brushwork, the effortless ease, and the delightful sense of touch make this work a refreshing variation from his fine line drawing.

The Thatched Cottage of Lake Fan is a wonderful example of Ren's landscape painting. Its mood is peaceful, and the restraint of his brushwork throughout the scroll evokes a stately quality. His patron Zhou Xian had long desired to construct an estate by the shore of the Fan Li Lake in his native-place Jiaxing. His ideal estate – which is indeed a dream that develops like a fable – has been represented textually and pictorially. Zhou himself painted a scroll which is now lost. This version by Ren is dated 1855. It bears a colophon written by Zhou Xian, dated 1858, which provides a literary description of his imaginary estate. The artist might have painted this scroll in accordance with specific information, if not the text, provided by Zhou. A third version, jointly painted by Tao Qi and others, is also in the Shanghai Museum.

Lady of River Xiang
Not dated

Hanging scroll, ink and colour on paper
121.4 x 35.3 cm
With artist's signature and 1 seal

right

*Cat Sleeping in the Shade of
the Banana Tree*
1856

Hanging scroll, ink and colour on paper
117.9 x 40.3 cm
With artist's inscription, signature, and 1
seal; 4 collectors' seals

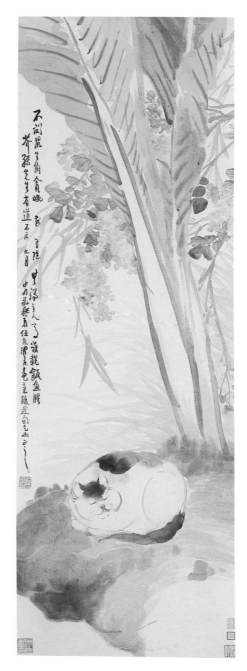

REN XIONG

1823–57

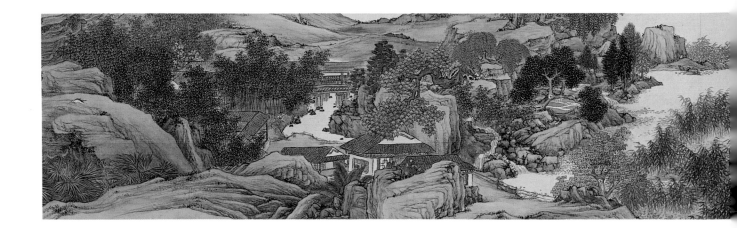

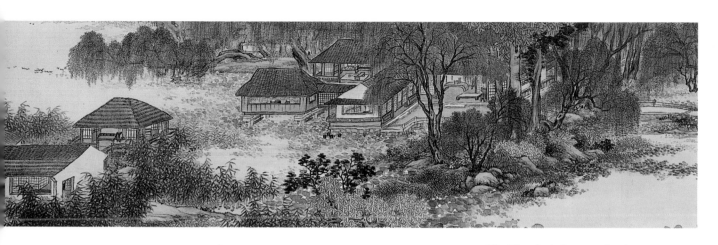

The Thatched Cottage of Lake Fan
1855

Handscroll, ink and colour on paper
35.8 x 705.4 cm
With artist's inscription, signature, and
1 seal

XUGU
1823-96

Xugu was a monk-artist who was active in Shanghai from about 1870. He was an itinerant travelling between Yangzhou, Suzhou and Shanghai. While no evidence suggests that Xugu was a member of any of the art associations, he was nevertheless well connected in the Shanghai art community. His circle of friends included Hu Yuan, Ren Yi and Gao Yong. His drawings had been used as designs for letter papers by the Jiuhuatang stationery store, whose owner Zhu Jintang was a patron-friend of the artist. As Xugu earned his reputation in Shanghai, seekers after his works were so plentiful that he would leave the city whenever he felt tired of painting. To him selling paintings was like 'begging money in the world for meals'.

Xugu was known for his eccentric behaviour as well as his unusual life history. His ancestral home was in Shexian, Anhui province, but he lived his early life in Yangzhou where he served as a military official and was appointed Assistant Regional Commander. He abandoned his military career at thirty and became a Buddhist monk during the Taiping Rebellion. The reason for his resignation and conversion to Buddhism is obscure. One source (*Haishang Molin*) says that Xugu was moved by deep emotion, whereas another (*Bianzhou Zayi*) states that Xugu made a sudden decision after he had been scolded by his father. In any case, this eccentric monk did not perform Buddhist rituals but took pleasure only in painting and calligraphy. He was a versatile artist and was skilled in painting portraits, landscapes, flowers, fruits, birds and animals.

A Long Day in the Silent Landscape shows Xugu's stylistic debt to the Anhui tradition of landscape painting, although the application of wet ink washes with his scribbling brush gives an effect of visual excitement that differs from the dry and spare rock forms of the earlier Anhui masters. Xugu's personal style expresses his intense inner feeling. His jagged and agitated brushstrokes create a sense of tautness that characterises his art.

Xugu reveals his personal visions of a completely quiet and austere natural world in *Landscapes*, dated 1883. This small album of twelve leaves is a marvellous work that he painted for his patron-friend Gao Yong. There is a cool sense of touch, which evokes a remote and lonesome mood, in each of the lightly tinted leaves. Immortals' lodgings hidden behind banana trees, a studio amidst wintry trees, a hermit in an autumn forest – all are portrayed with the greatest sensitivity.

Of all the subjects painted by Xugu, his squirrel and goldfish are the most famous. Inspired by the eighteenth-century artist Hua Yan, Xugu captures the delightful charm of the agile animal in *Squirrel*. A round head with two enlarged eyes and a curving body with a bushy tail, his squirrel image is a simple but graceful composition of geometric shapes and elegant curves. In the *Goldfish in Spring Water*, the goldfish have bulging eyes and simple, geometric shapes for bodies. The repetition of these striking imageries, especially in the late works of Xugu, suggests that they were particularly acceptable to the patrons in Shanghai.

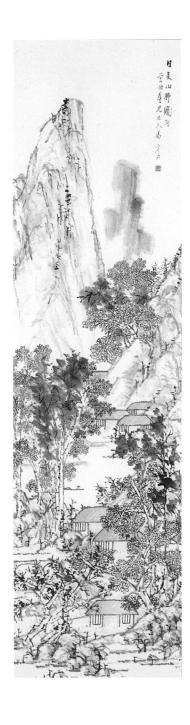

A Long Day in the Silent Landscape
Not dated

Hanging scroll, ink on paper
147 x 40 cm
With artist's inscription, signature, and
2 seals

C
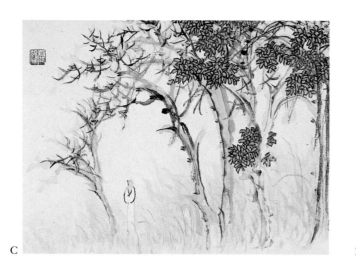

F

G

H

Landscapes
1883

Album of twelve leaves, ink and colour
on paper
Each leaf 18.9 x 25.4 cm
With artist's inscription, signature, and 12
seals; 1 collector's seal

Squirrel
1892

Hanging scroll, ink and colour on paper
149.8 x 40.4 cm
With artist's inscription, signature, and
2 seals; 1 collector's seal

Gift of Qian Jingtang

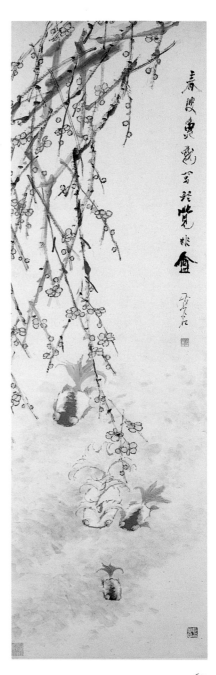

right
Goldfish in Spring Water
Not dated

Hanging scroll, ink and colour on paper
129.4 x 39.9 cm
With artist's inscription, signature, and 2
seals; 1 collector's seal

ZHU CHENG
1826-1900

Zhu Cheng was the younger brother of Zhu Xiong, twenty-five years his senior. The two were active in Shanghai by 1862 and participated in the artistic gatherings of the Duckweed Society. Zhu Cheng had painted jointly with Wang Li and other artists during these gatherings.

Initially, Zhu Cheng studied painting under Zhang Xiong. Zhu's copies of his master's works were so faithful that even Zhang could not distinguish them from his own. Later, when Wang Li established fame in Shanghai, Zhu modelled his styles after Wang Li, preferring the immediacy of Wang's art to the delicacy of Zhang's. He made great progress in painting after the age of fifty. According to Zhang Mingke's account in the *Hansongge Tanyi Suolu*, Zhu became so famous that demand for his works was tremendous. He was weary of painting to meet the ceaseless demands for small-scale works. Despite increasing prices, there were still endless requests for his paintings.

Birds and Plants, a set of four hanging scrolls dated 1871, exemplifies the bold, powerful, and unsophisticated style that gained wide acceptance in Shanghai at that time. Zhu was in fact following the trend set by Wang Li. Scale and monumentality characterise this set, in terms of the images and the paintings themselves. The array of colourful subjects suggests that these works appealed to the commercial art market.

The painting *Peach Blossoms and Birds* is undated. The uninhibited style suggests that this is a late work in which Zhu frees himself from the powerful, stiff manner of depiction in the earlier set. The inscription states that Hua Yan was the source of inspiration, and Zhu attains a similar sense of intimate immediacy in his portrayal. Nevertheless, the jagged brushwork, which produces criss-cross branches of the flowering tree, is totally different from Hua Yan's. The artist essentially paints in his own style.

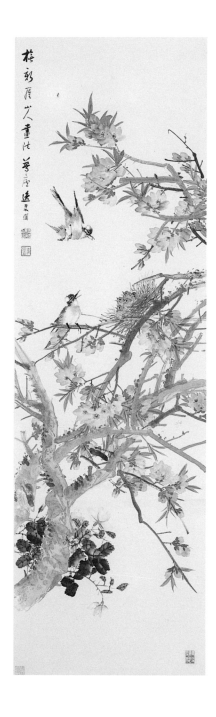

Peach Blossoms and Birds
Not dated

Hanging scroll, ink and colour on paper
164.5 x 46.7 cm
With artist's inscription, signature, and 3
seals; 1 collector's seal

Gift of Qian Jingtang

ZHU CHENG
1826–1900

Birds and Trees
1871

A set of four hanging scrolls, ink and
colour on paper
Each scroll 177 x 61.5 cm
With artist's inscriptions, signatures,
and 8 seals (2 on each scroll)

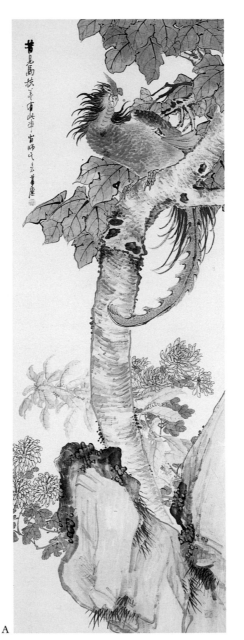

A

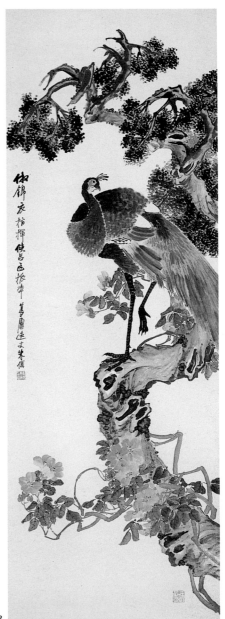

B

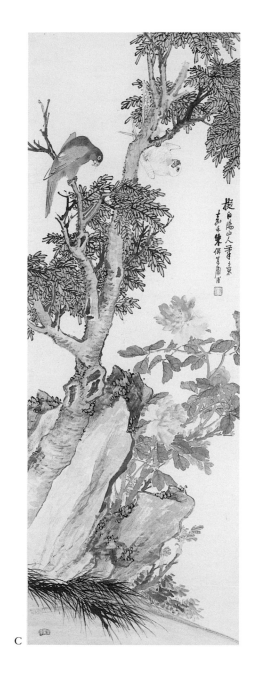

C

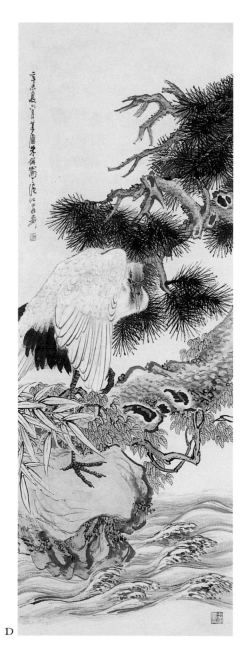

D

ZHAO ZHIQIAN
1829-84

The experience of living in a turbulent era undoubtedly lent emotional intensity to the works of Zhao Zhiqian, an artist of extraordinary originality. Zhao stood out as a *jinshi* painter and calligrapher who turned to tradition and borrowed from the remote past to express himself in art. He chose a style evoking strength, power and vitality.

Zhao Zhiqian was born in Kuaiji (Shaoxing), Zhejiang province. His stays in Shanghai were brief. He only went there occasionally, leaving behind works that were highly regarded by his audience. In fact, Zhao Zhiqian pursued an official career and obtained the provincial degree (*juren*) in 1859. Unfortunately, he failed the metropolitan examination in Beijing, because his style of writing did not conform to the aesthetic standards favoured within the court. He was later appointed to a low position in Jiangxi, compiling the gazetteer (1873-81) and working as a district magistrate in Panyang, Fengxing and Nancheng. He died in Nancheng in 1884, after the further misfortune of being caught up in the Sino-French War.

The troubled life of Zhao Zhiqian was tied up with the decline of the Qing dynasty, which brought disturbances of various sorts to the populace. Zhao experienced the turmoil of the Taiping Rebellion in which he lost his teacher, his wife and daughter. He was saddened by the fact that the Qing court unjustly accused his teacher Miao Zhi of failing to assume duties during the chaos and deprived him of all honours after his death. Zhao petitioned the court on behalf of his teacher. And when his wife and daughter died in Kuaiji, Zhao sank into melancholy and adopted the sobriquet of Bei'an (The Studio of Sorrow).

Zhao Zhiqian's interests covered many fields, including literature, philology, epigraphy, seal carving, painting and calligraphy. As a scholar, he was proficient in *kaozheng* scholarship and was concerned with critical empirical investigation. Thus Zhao became devoted to the studies of such archaeological materials as bronze and stele inscriptions. As a calligrapher he first studied the works of Yan Zhenqing and later followed the *beixue* or stele school under the influence of Deng Shiru and Bao Shichen. As a seal-engraver he admired Ding Jing (1695-1765) and followed the styles of the Qin and the Han. As a painter he was inspired by the expressionist modes of Chen Shun, Xu Wei, Zhu Da and Li Shan. Later he developed his *jinshi* approach to painting. Not only did Zhao ventured into calligraphy, seal carving and painting, he attempted to synthesise the three art forms, which lent new life to his art.

The album *Flowers* was painted in 1859. Even in this early phase, he had a penchant for the subtle, resistant movement of the brush. Each of his strokes is charged with inner tension and dynamism and is written with restraint and control, absolutely free from over-performance. This is evident in both his calligraphy and painting. The varied pictorial compositions of the twelve leaves are carefully planned, due probably to Zhao's proficiency in seal carving which requires the skill of designing self-contained structural units on a small surface. As for the flowers, the colours are particularly vibrant. Sensitive tonal gradations give weight and density to the blossoms of various kinds.

The painting *Peaches and Peonies*, dated 1870, demonstrates a more relaxed style than the 1859 album. Although the brush appears to move more freely in this painting, there is an unfailing sense of vigour and strength in the brushwork, typical of Zhao's hand. The solid rendering of the fruits and blossoms adds to the intensity of his work.

Similarly in *Chrysanthemums* the robust rendering endows the flowers with vital energy. The blossoms are depicted in

various modes: opaque colouring, 'boneless' manner and pure outlining. Although this painting is not dated, the calligraphy suggests a date in the 1870s.

Bookstack Cliff is a unique landscape painting in which the natural appearance of a cliff has been transformed into repetitive patterns of brushwork. This painting was done at the command of his patron-friend Pan Zuyin (1830-90). The rocks are portrayed with 'devil's face' texture strokes (*cun*) that build up the cliff in which stacks of books are found. The clusters of pine needles echo the numerous rounded lumps. With the exception of the flowing lines of the water, the painting is drawn with short, staccato strokes caught in a warm colour range (the cliff) and with lines drawn in deliberate pace and rhythm (the pine). Active kinetic energy penetrates the work, evoking the mood of restlessness typical of the period.

Bookstack Cliff
Not dated

Hanging scroll, ink and colour on paper
69.5 x 39 cm
With artist's inscription, signature, and
1 seal

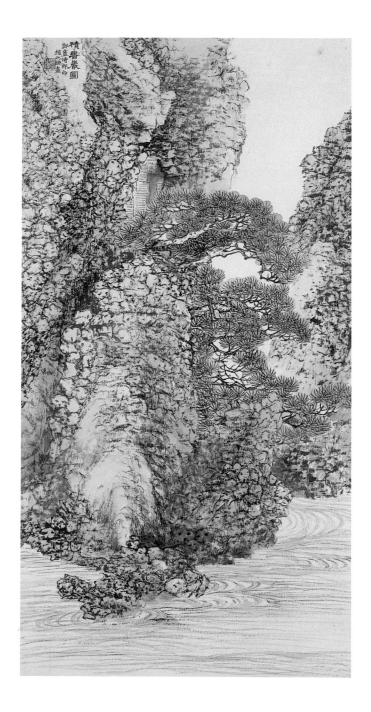

ZHAO ZHIQIAN
1829-84

Flowers
1859

Album of twelve leaves, ink and colour
on paper
Each leaf 22.4 x 31.5 cm
With artist's inscriptions, signatures, and
12 seals (1 on each leaf); 1 collector's seal

B

D

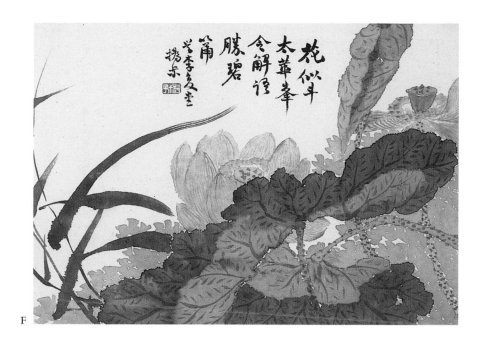

花似斗
太華峯
念解譯
勝碧
筆
學李復堂
攋朱

F

J

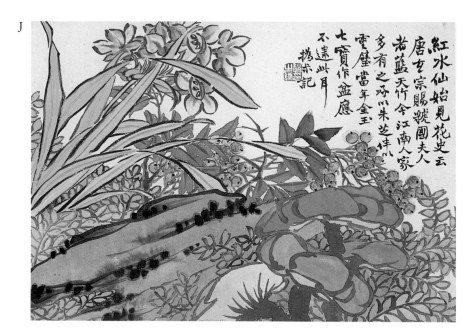

紅水仙始見花史云
唐玄宗賜虢國夫人
尚藍天竹今江南人家
多有之邪以朱芝伴以
雲壁當年金玉
七寶作盆應
不遠此月
攋朱記

ZHAO ZHIQIAN
1829–84

Peaches and Peonies
1870

Hanging scroll, ink and colour on paper
175.3 x 93.8 cm
With artist's inscription, signature, and 2
seals; 4 collectors' seals

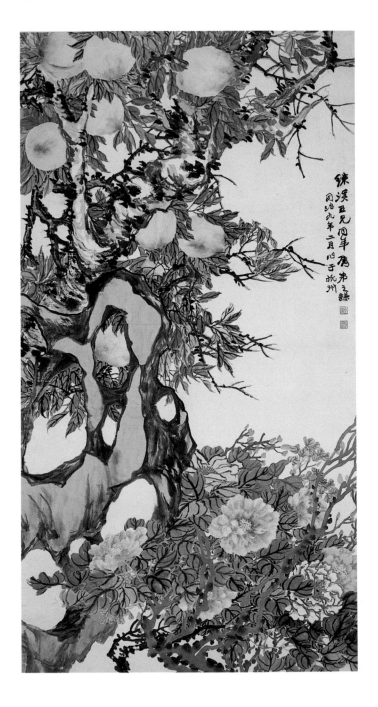

Chrysanthemums
Not dated

Hanging scroll, ink and colour on paper
133.5 x 32.6 cm
With artist's inscription, signature, and
1 seal

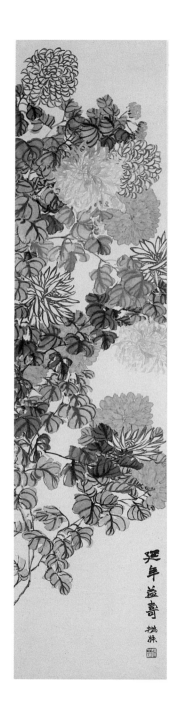

Pu Hua
1832-1911

Pu Hua came from Jiaxing and moved to Shanghai in the 1870s. As noted by Zhang Mingke in *Hansongge Tanyi Suolu*, both Pu Hua and the author were the students of Wan Qingli, Provincial Educational Commissioner of Zhejiang. Pu Hua left home after the death of his wife in 1864 and went to Ningbo. He had served as clerk in various localities for more than a decade. His stay at Ningbo was his longest – he was still at the city in 1872 making an inscription on Ren Yi's famous painting *Saying Farewell at the Ling Bridge, Ningbo*. After his stay at Ningbo, he settled in Shanghai and sold paintings to support himself.

The *Haishang Molin* records that Pu Hua's residence, the Studio of Nine Zithers and Ten Inkstones, was located among brothels in the northern district of Shanghai. The lone artist, with no family, would paint in his studio regardless of the laughter and clamour at midnight. Pu Hua was uninhibited in both his lifestyle and his arts. He did not bother about his financial returns and often let his patrons obtain his works at low prices. It was only after his death that prices of his works suddenly rose tremendously. In art, Pu Hua pursued a very free and expressive style. He also excelled in cursive script, and his brushwork was, according to Yang Yi, as exuberant as a heavenly horse soaring across the skies. His styles were unique in his time, and seekers of his works included the Japanese.

The array of colourful subjects in *Fish Pelargonium and Narcissus* typifies the quest for visual appeal in many paintings in late Qing Shanghai. Yet Pu Hua adopts an individual approach to his use of the brush and develops a bold and unrestrained style. His mode of using highly expressive strokes to create animated forms, then adding bright colours to give an enchanting appearance of subjects exerted an impact on Wu Changshuo. In *Twin Lotus in the Calamus Pond*, dated 1904, both composition and brushwork exhibit a firm control that characterise the late work. *Snowy Mountain* is a wonderful example of Pu Hua's landscape painting. It shows how the artist expresses the feeling of exhilaration with his brush and ink plays. Although he cites Tang Yin (1470-1524) as the exemplar in his inscription, he is working essentially in his own style.

Fish Pelargonium and Narcissus
Not dated

Hanging scroll, ink and colour on paper
146.3 x 77.1 cm
With artist's inscription, signature, and
2 seals; 1 collector's seal

Gift of Qian Jingtang

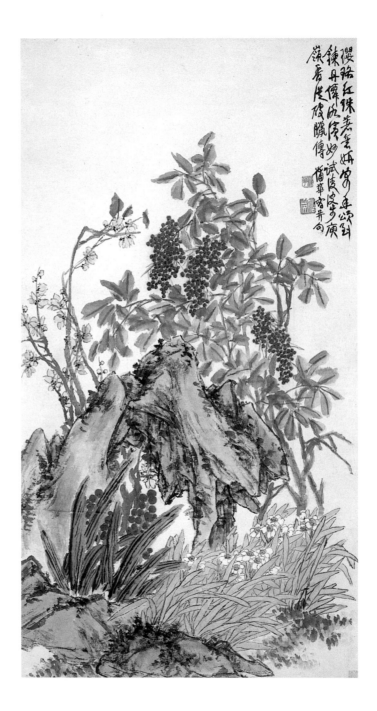

PU HUA
1832–1911

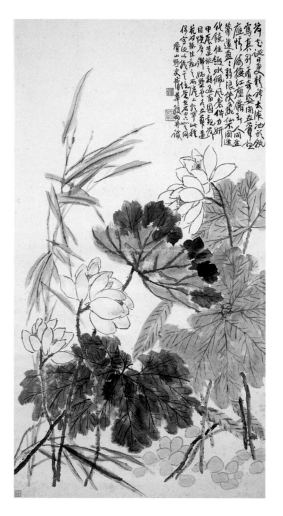

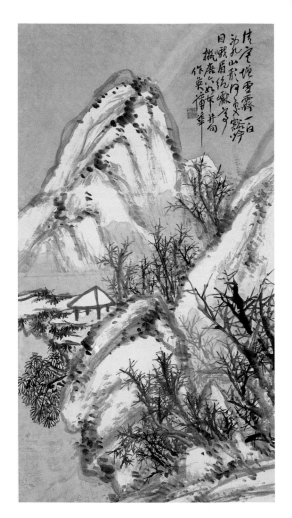

Twin Lotus in the Calamus Pond
1904

Hanging scroll, ink and colour on paper
147 x 77 cm
With artist's inscription, signature, and 2
seals; 1 collector's seal

Snowy Mountain
Not dated

Hanging scroll, ink and colour on paper
147.8 x 80.4 cm
With artist's inscription, signature, and
1 seal

SHA FU
1831–1906

The Suzhou artist Sha Fu specialised in the depiction of figures, flowers and insects. He worked in his native province but would travel to Shanghai occasionally. Biographical records are scanty, but it is known that he was a student of Ma Genxian who was famous for his paintings of refined ladies and of floral subjects. Moreover, Sha Fu and his younger brother Sha Ying had studied with Ren Xiong. Whereas his brother continued with the *gongbi* (meticulous) manner of Ren, Sha Fu was drawn to the elegant mode of Gai Qi and Fei Danxu in figural depiction. (He believed that he could not rival Ren Xun in painting after the style of Chen Hongshou.) When depicting floral subjects, Sha favoured an elegant style. The insects he paints are lively and intricate, and it has been suggested that Ren Yi learned from him in this sub-genre. The relationship of the two is supported by the *Portrait of Sha Fu at Thirty-nine sui*, painted by Ren Yi at Suzhou in 1868.

The quest for purity and elegance in Sha Fu's floral paintings is illustrated in the *Withered Lotus,* a painting done after Chen Shun. Here, there is a balance between the disparate motifs in the lotus pond – blossoms, leaves, stalks, neighbouring plants and ripples – so that they interact with each other to form a

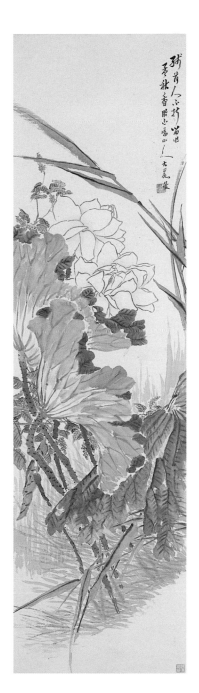

cohesive structure. Suffused areas of ink wash and broad brushstrokes define the varied shapes of the withered leaves at the end of the lotus cycle. An overall linear rhythm adds to the beauty of the scene.

Withered Lotus
Not dated

Hanging scroll, ink and colour on paper
151 x 41.3 cm
With artist's inscription, signature, and
1 seal; 1 collector's seal
Gift of Qian Jingtang

QIAN HUI'AN
1833-1911

Qian Hui'an was renowned for his *gongbi* (meticulous) style in painting beautiful ladies and other figural subjects. The art critic Zhang Mingke complimented him on this particular genre. Besides figures, Qian Hui'an also painted portraits, flowers, plants and landscapes.

Qian Hui'an was a Baoshan native, active in Shanghai for a considerable period of time. The artist was a member of the Duckweed Society, and he collaborated with Bao Dong and Wang Li in painting the scroll to commemorate the gathering in 1864. His painting in Shanghai might have begun well before the Duckweed Society turned into a painting society in 1862, as the artist had studied painting with Li Xi in Shanghai. Qian Hui'an was also the first chairman of the Yu Garden Charitable Association of Calligraphy and Painting, founded in 1909. According to the *Haishang Molin*, he came to the office on the first and the fifteenth days of every month and often encouraged the other members by his moral attitude.

Acquiring Words is a mature work of Qian's in the genre of figure painting. It depicts the pleasurable life of a man in his humble estate, with his wife asking him unfamiliar words while reciting the classics and his son offering wine. As clearly described in the inscription, it is a

work after Hua Yan. Painted in 1902, this painting shows the angular brushwork that typifies Qian's late style in figural representation. Denying the natural flow of fluent lines, his strokes are vigorous, spiky and broken, producing an overall sketchy effect. Also notable is Qian's idiosyncratic mode of presenting faces.

Lotus exemplifies Yang Yi's observation that Qian was original when he painted floral subjects. The broad wet ink and colour washes, which strive for movement and spontaneity, make his flowers very different from the strong linear qualities of his figural subjects.

Acquiring Words
1902

Hanging scroll, ink and colour on paper
149.5 x 40.6 cm
With artist's inscription, signature, 3 seals;
1 collector's seal
Gift of Qian Jingtang

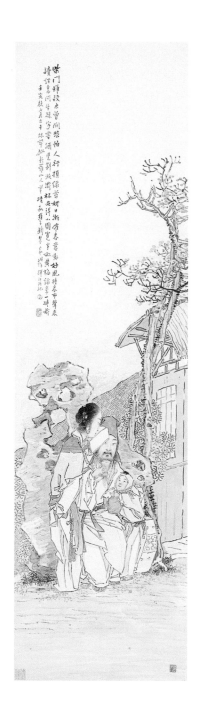

right
Lotus
Not dated

Hanging scroll, ink and colour on paper
133.1 x 31.1 cm
With artist's inscription, signature, and 1
seal; 2 collectors' seals

WU DACHENG
1835-1902

Unlike those professional painters who sold their works to support themselves, Wu Dacheng was an amateur artist. He was a scholar-official and collector, as well as patron of the arts. He resided in Shanghai temporarily in his early and later years and was associated with famous artists from Jiangsu and Zhejiang provinces.

Wu came from Suzhou and went to Shanghai in 1860 during the Taiping Rebellion and participated in the literary and artistic gatherings of the Duckweed Society. His stay in Shanghai was brief, because of his travels to Beijing and to Suzhou to attend the civil service examination. In 1868 Wu obtained the *jinshi* degree (a status often compared to the academic doctorate in the modern West) and became Bachelor of the Hanlin Academy. He assumed official duties at various places in the 1870s and served respectively as Secretary of Li Hongzhang (1823-1901) in Hubei, Educational Commissioner in Shaanxi and Gansu, and Circuit Superintendent in Henan. In the 1880s he was despatched several times to defend the borders and to handle foreign affairs with Russian, Korean and Japanese officials. He also worked in Tianjin and assisted Li Hongzhang in concluding the Sino-Japanese convention of 1885. Wu was appointed Governor of Guangdong

in 1887, Director-General of Yellow River and Grand Canal Conservancy in 1888, and Governor of Hunan in 1892. During the Sino-Japanese War (1894-5), he led a troop to defend Shanhaiguan in the frontier but met a defeat that deprived him of his post. He returned to his former position in Hunan. Soon afterwards, he retired and served as Director of the Longmen Academy in Shanghai. He suffered from paralysis in 1899 and died in 1902.

Wu took an active interest in collecting ancient objects and had a rich collection of archaic bronzes, seals, jades, calligraphy and paintings. He compiled catalogues based on his critical studies of these objects and researched on philological and archaeological topics. He also composed poetry and practised calligraphy, painting and seal carving at leisure.

Mount Tongguan, dated 1866, is one of Wu's early works done before he obtained the *jinshi* degree. After twenty-five years, Wu happened to see this painting again and added another inscription remarking on the lack of profound skill in spite of the apparent richness and vigour in the early stage of his art. This self-deprecatory remark should perhaps be put in the context of the artist having accumulated experience from the studies of ancient inscriptions on bronzes and steles, which

had provided him with new views on the brush method. Depicted here is Mount Tongguan after Wu's travel to the mountain, famous for its copper. But it seems that it is the brush idiom of Shen Zhou, on which this work is modelled, rather than the topographical speciality, that captures the interest of the artist. There is not the effect of coarse sturdiness that is to be found in Shen Zhou's brushwork. Surprisingly, as noted by Xu Kang in the inscription dated 1877, this work resembles, instead, the landscapes of Gong Xian (c1619-89). This may be due to his use of the darkened moss dots to accentuate the rocks – a characteristic feature in Gong Xian's mountain configuration – as well as the sensitive tonal gradations so that the mountains are bathed in light and mist, evoking a quietude which reminds us of Gong Xian's bleak, desolate landscape. This painting has been owned by Jin Lan (b1841) who added an inscription in 1909 explaining the exceptional opportunity of possessing a work by Wu Dacheng, whose paintings were regarded as extremely valuable by connoisseurs.

Mount Tongguan
1866

Hanging scroll, ink and colour on paper
131 x 31.4 cm
With artist's 2 inscriptions, signatures, and
2 seals; inscription and 1 seal of Xu Kang
(19C); inscription and 1 seal of Jin Lan (b
1841); 3 collectors' seals

Gift of Qian Jingtang

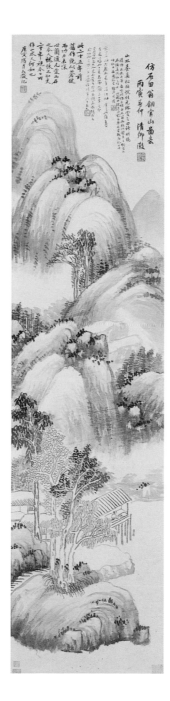

GU YUN
1835–96

Gu Yun was a landscape painter from Suzhou, who followed the orthodox tradition of the Four Wangs, Yun Shouping and Wu Li. Little is known about him except that he had been employed to paint for the Circuit Superintendent of Susong (Suzhou and Songjiang). He was one of the nine artists known as the 'Nine Friends of Suzhou'. The others were Wu Dacheng, Gu Linshi, Lu Hui, Ren Yu, Hu Xigui, Wu Guxiang, Ni Tian and Jin Lan.

Literary Gathering by a Stream, dated 1857, is based on the prototype by Wang Meng (c1308–85), one of the Four Great Yuan Masters. Although the crowded composition and the woolly texture strokes of the mountains are derived from Wang Meng, the painting is the product of a new age, revealing the stylistic trends of Gu Yun's time. Here, the articulation of a predominant structure in landscape configuration is based on the composition scheme of the Qing orthodox school. When executed with these dense brushstrokes, it gives the impression of a complex, vibrant organism.

Studies of past paintings played a decisive role in the way Gu Yun developed his style, and he too drew inspiration from the Wu School masters. *Pleasures by the Autumn Pavilion* is a copy of the painting that accompanies the poems composed by Shen Zhou, Wen Zhengming, Wu Kuan, Gu Dadian and Tang Yin – a work once owned by Gu Yun. Despite the purity and elegance in Gu's landscape depiction, there is occasionally a weak handling of the brush.

Literary Gathering by a Stream
1857

Hanging scroll, ink and light colour on
paper
135.7 x 52 cm
With artist's inscription, signature, and
1 seal

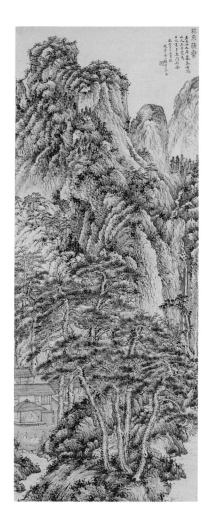

Pleasures by the Autumn Pavilion
Not dated

Handscroll, ink and colour on paper
24.6 x 131 cm
With artist's inscription, signature, and
3 seals
Gift of Pan Dayu

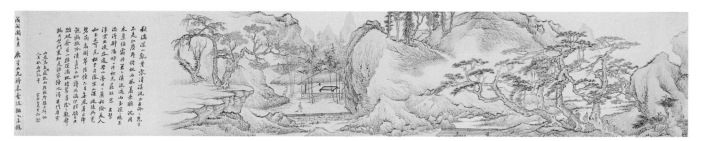

FEI YIGENG
19C

Fei Yigeng was a successor of Fei Danxu (1801-50) in kinship and in art. His father, a native of Wucheng, Zhejiang province, specialised in the genre of beautiful women and sold paintings in various cities in Zhejiang and in Jiangsu. He had lived in Hangzhou for a long period and travelled to Shanghai occasionally during the Daoguang reign (1821-50). One may assume that the youthful Fei followed his father to these various places.

Biographical information on Fei Yigeng confirms that he resided at the Zhenyitang Studio of the Wang family in Hangzhou, which housed a rich private collection of books. At the request of his host, Wang Yuansun (1794-1836), Fei Yigeng painted a monumental work commemorating a literary gathering of twenty-seven poets in the East Gallery of Wang's residence. In 1868 Fei travelled to Beijing with Zhang Mingke, and in 1870 he was in Shanghai drawing *Zhong Kui Listening to Music*; he dedicated the work to Zhang. He died shortly after this meeting with Zhang in Shanghai.

Inheriting the art of his father, Fei specialised in the genres of portraiture and of beautiful women. He also painted landscapes and floral subjects as the backdrop to his figural depiction. Since his father's manner of depicting women was very popular and was followed by many other artists, Fei Yigeng was working in a competitive environment when using his father's style. The gifted artist Ren Yi, for example, modelled his figure paintings on Fei Danxu's and even called himself Xiaolou (Little Tower) to stress his continuation of the style of Fei Danxu, whose *zi* or literary name was Xiaolou (The Tower at Dawn). It has been suggested by Qian Jingtang (1907-83), a famous art collector in Shanghai, that Fei Yigeng objected to Ren Yi's adoption of the name Xiaolou.

Fei Yigeng's paintings of women were praised by Zhang Mingke for their quality of secluded serenity. This is clearly illustrated in *Washing Yarn in the River*, dated 1867. The theme alludes to an old belief that Xi Shi of Yue, one of the most beautiful ladies in the Spring and Autumn Period (770-476 BC), washed yarns by the River Ruoxie in Shaoxing, Zhejiang.

Washing Yarn in the River
1867

Hanging scroll, ink and colour on paper
161.5 x 45 cm
With artist's inscription, signature, and 1
seal; 1 collector's seal

Gift of Qian Jingtang

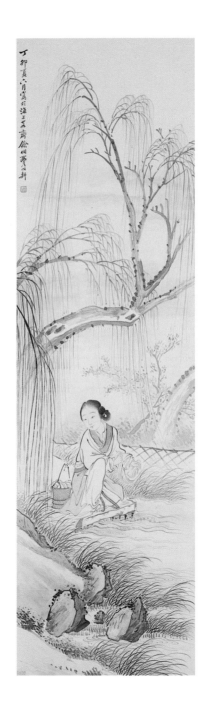

Ren Xun

1834-93

Ren Xun was one of the Ren clan who exerted such an impact in the Shanghai art scene. His individual achievement seemed to be overshadowed by those of his brother Ren Xiong and of his student Ren Yi, but he nevertheless played an important role in transmitting his brother's styles in a creative manner that paved the way for Ren Yi. By the 1870s Ren Xun had established his reputation and was known for his paintings of figures, flowers and birds.

Ren's versatile skill in floral and animal depiction is demonstrated in *Peonies and Pheasant* as well as *Hawk and Cockerel*. The subjects in the former are rendered with fine outlines, creating a network of angular strokes, which suggests that his work, like Ren Xiong's, could serve as a design for prints. To overcome the flatness of schematic forms, he imbues them with volume and with a sense of modelling. The textural plays are achieved by subtle nuances and suffusions of colour values, whereas the colouring is done in a stately manner recalling the Northern Song tradition.

Without limiting himself to the fine-line technique, Ren employs the *xieyi* style (literally, writing the ideas), which emphasises spontaneity and free expression, in the *Hawk and Cockerel*. Fluid brushstrokes and pale ink washes give his work a softness of touch, and his free, spontaneous style exerted great influence on the art of Ren Yi, especially in the genre of flower and bird painting.

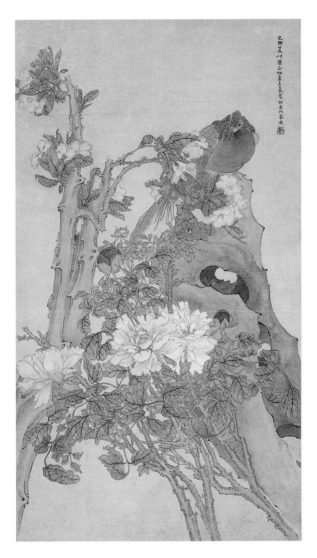

Peonies and Pheasant
1879

Hanging scroll, ink and colour on paper
146.6 x 80.1 cm
With artist's inscription, signature, and
1 seal

Hawk and Cockerel
1885

Hanging scroll, ink and colour on silk
137.3 x 70.9 cm
With artist's inscription, signature, and
1 seal

YANG BORUN
1837–1911

The artist's original name was Yang Peifu, but he was commonly known by his *zi* (literary name), Borun. Like Hu Yuan, Yang Borun studied painting with Shen Zhuo and was a specialist landscape painter in Shanghai. However, he was not as influential as Hu Yuan.

Yang was born into a well-to-do scholar family in Jiaxing. His father Yang Yun was a poet, calligrapher and painter, whose mansion, the Water Kiosk by the South Lake, was frequented by scholars and artists of the day. Moreover, his family owned a collection of paintings and calligraphy, which gave him the opportunity to study ancient works of art from an early age.

During the early 1860s Yang fled to Shanghai to escape the Taiping Rebellion. He sold paintings to support his mother and befriended artists like Ren Yi, Xugu and Wu Changshuo. Later he became the Chairman of the Yu Garden Charitable Association of Calligraphy and Painting.

Yang painted the album *Landscapes* in imitation of a range of earlier models. Despite the diversity, these ten album leaves reveal a consistent style of the artist: the use of long spiky strokes and shading to create an overall smoky effect of his landscapes. An interesting comparison can be drawn between Yang Borun's and Hu Yuan's brushwork. Both have the tendency to apply sweeping strokes over wash-laden surfaces. The art critic Zhang Mingke has noted that Yang followed the manner of Dong Qichang, but this set of works lack the tight structures and variations to be found in Dong's landscape constructions.

Landscapes
1884

Album of ten leaves, ink on paper
Each leaf 29.7 x 32.9 cm
With artist's inscriptions, signatures, and
10 seals; 9 collectors' seals
Gift of Qian Jingtang

A

E

HU XIGUI
1839-83

Hu Xigui was a specialist in figure painting, especially in the sub-genre of beautiful women. He came from Suzhou, and he with eight other artists were known as the 'Nine Friends of Suzhou'. Little is known about his life or his activities in Shanghai.

Lady under Banana Tree and Bamboo, dated 1881, reveals the stylistic influence of Hua Yan in Hu's figure painting. This is evident in the dragging lines, of varied thickness, which the artist uses to render the draperies. Hu also follows the manner of Gai Qi and Fei Danxu in the depiction of female beauty: a lady with oval face and sloping shoulders which had become the vogue for beauty in nineteenth-century paintings. Hu captures the mood of the scene: the night breeze blows; the banana leaves and bamboo sway gently.

The pure, soft touch perfectly evokes the quality of secluded tranquillity. This painting bears an inscription by Gu Linshi (1865-1930), which testifies to the friendship of the two artists. Recalling how he enjoyed discussing art topics with Hu at the Yi Garden during the spring of 1883, Gu lamented the premature death of Hu in the autumn of that year.

Lady under Banana Tree and Bamboo
1881

Hanging scroll, ink and colour on paper
101.6 x 32.7 cm
With artist's inscription, signature, and
1 seal; 1 collector's seal

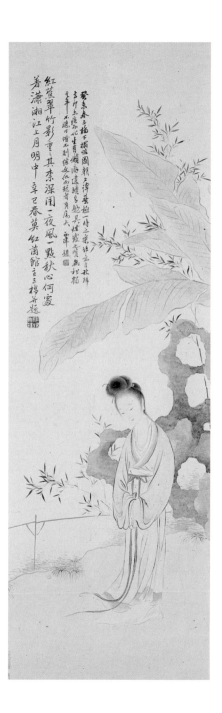

WU JIAYOU
1840-c1893

Wu Jiayou was an unusually political artist. His drawings, especially those published in pictorial magazines, successfully roused public awareness of contemporary affairs in an era of drastic political and social changes. This paved the way for the use of visual images to disseminate new political and social ideas to broad masses of the populace in the following century. Although his art brought new social meaning in late nineteenth-century Shanghai, it was rooted in tradition. In expanding the scope of his subjects and borrowing representational techniques from the West, Wu introduced a new dimension to Chinese painting.

Born in Yuanhe (present-day Suzhou), Jiangsu province, Wu Jiayou had studied painting since his youth. He specialised in the *gongbi* (meticulous) manner of depiction, excelling in renditions of figures, portraits, landscapes, flowers, birds and animals.

Wu Jiayou established his fame in Shanghai from about 1880. In that year he was commissioned to portray the *Banquet at the Yu Garden*. Since the participants of the banquet were officials and prestigious figures of the day, one may assume that this provided him with the opportunity to establish connections with the social elite, which allowed him to obtain other commissions. Recent studies reveal that Wu Jiayou was commissioned in 1886 to render the military success of the Hunan Militia in the suppression of the Taiping rebels. His depictions of the battles were intended for use within the court academy as prototypes. Wu also painted portraits of officials and military generals who had participated in this campaign. Whether the artist had been summoned to court service is yet to be discovered.

In 1884 Wu was employed to draw lithographic illustrations for the *Dianshizhai Huabao*, the pictorial distributed with the Shanghai newspaper *Shenbao*. And in 1890-92 he published his own pictorial entitled *Feiyingge Huabao*. Since he was painting for a wide audience, his range of subjects was extremely broad, including scenes of daily lives, novelties in Shanghai, beautiful ladies, children at play, contemporary events in foreign countries, episodes in dramas and fictions, historical and mythical figures, flowers, birds and animals. His genre paintings were particularly popular. Depicted with the greatest sensitivity, these paintings present aspects of life in late Qing Shanghai. There was no attempt to lament nor exaggerate; he simply recorded the realities of life. His social consciousness and, often, his sense of humour were revealed in these paintings.

In the album *Ladies*, dated 1890, each of the twelve leaves depicts a leisurely activity of a beautiful lady, suggesting their grace and elegance. Although there has been a long tradition of depicting elegant ladies in Chinese figure painting, Wu Jiayou makes clever use of the costumes and the hairstyles to relate his figural subjects to contemporary Shanghai ladies. The emphasis of the substance of the physical bodies reveals the Western influence. In Leaf A, for example, it is rather unusual for the Chinese painter to show the female bodies underneath the transparent clothes.

Ladies
1890

Album of twelve leaves, ink and colour on silk
Each leaf 27.2 x 33.3 cm
With artist's inscriptions, signatures,
15 seals; 2 collectors' seals

A

D

Wu Tao
1840–c1897

Wu Tao was a calligrapher, painter and poet from Shimen (present-day Chongde), Zhejiang province. The art critic Zhang Mingke praised him highly by saying that he was a man of lofty character, who locked himself in his studio, the Thatched Hut for Returning Egrets, painting throughout the year. Yang Yi noted that Wu did not seek fame and wealth. Ironically, Wu Tao's reputation spread across the south-east and seekers of his paintings were always gathering at his doorstep. Wu befriended the scholar-official artist Feng Xuefeng, and also knew Zhang Mingke, a friend of Feng. When Zhang visited the monk-artist Xugu in Shanghai in 1893, Wu painted *Visiting a Monk in Shanghai* for Zhang.

Why was Wu presented in the literature as a recluse who was not attracted to fame? This was probably due to the tendency of the Chinese writer or art critic to associate the quality of painting with an artist's character. Wu's paintings, especially landscapes, were considered as the works of a great master. Mostly monochrome works, Wu's landscapes are grave, sombre, rich and elegant, as exemplified in the album *Landscapes* painted in 1894 and 1897.

Wu's floral depictions show a degree of substance and intensity, clearly illustrated in *Narcissus,* 1893, in which the fragrant blossoms are rendered with heavy brushwork and are given considerable weight. Whereas the narcissus are delineated in the *baimiao* style (ink line drawing), the rocks are rendered with the layering of ink washes. The contrast adds lustre to the flowers.

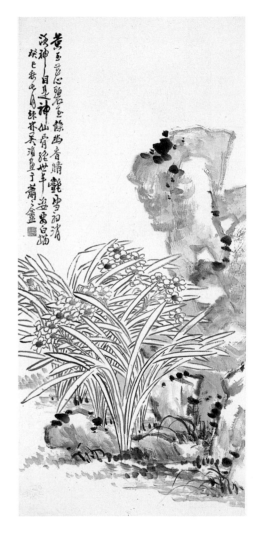

Narcissus
1893

Hanging scroll, ink on paper
110.8 x 50.6 cm
With artist's inscription, signature, and
1 seal

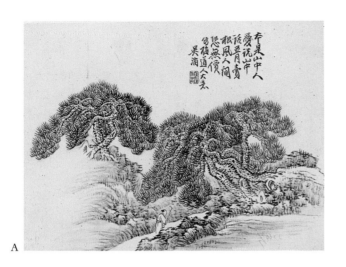

A

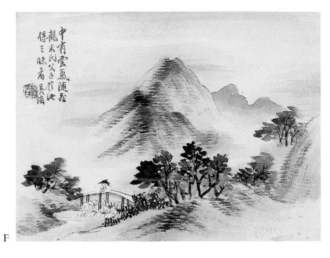

F

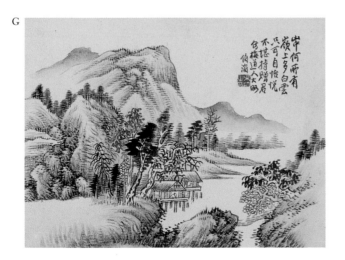

G

Landscapes
1894 and 1897

Album of nine leaves, ink on paper
Each leaf 27.2 x 35.5 cm
With artist's inscriptions, signatures, and
9 seals (1 on each leaf)

Ren Yi
1840-95

Ren Yi, commonly known as Ren Bonian, was a major artist in Shanghai; his reputation had been established since the 1870s. This is confirmed by Wang Tao, a contemporary journalist, in the *Xingruan Zazhi*.

Although the ancestral home of Ren Yi was in Shanyin, his family had moved to Xiaoshan. His father was a portraitist who gave the youthful Ren Yi useful training by asking him to do preliminary drawings of clients from life. The chaos of the Taiping Rebellion led to his separation from his father who later died in the turmoil. Ren Yi was also drawn into the rebellion and was assigned the task of bearing the flag for the rebels. His participation did not last long.

Saying has it that the youthful Ren Yi faked Ren Xiong's paintings in Shanghai and was caught by Ren Xiong who not only forgave him but also directed him to Suzhou to seek guidance from Ren Xun. If so, this encounter must have occurred before the death of Ren Xiong in 1857, well before Ren Yi served as a flag-bearer during the Taiping Rebellion. Whether or not this was true, the artist was definitely a successor of the elder Rens. A round fan painting done jointly by Ren Xun, Ren Yi and others in 1864, now in the Shanghai Museum, confirms that their teacher-student relation had started in or before that year. The two Rens had travelled together to Ningbo and Zhenhai for a couple of years. In 1868 Ren Yi left his teacher and went to Shanghai. With the recognition and support of Hu Yuan and of Zhang Xiong, he rapidly gained reputation in Shanghai.

Ren Yi mastered a wide range of subjects and techniques in painting. *Portrait of Gao Yong* best demonstrates his adoption of the Western techniques in portrait painting. Besides featuring the concavities and convexities of the face, there is also a concern for the physical body underneath the robe. Notably, this painting is a document of the connection between artists in Shanghai. Gao Yong was the patron, Ren Yi made the portrait, Hu Yuan filled the background, and Yang Borun added the inscription. A later inscription was written by the artist Wang Ti (1878-1960).

Stylistically, both *Fisherman* and *Zhong Kui* show the conscious attempt of Ren to give substance to the body form, which further supports our argument of the Western influence in his art. Ren's ability to capture the stance of his figural subject is due to his early training in sketches from life and the impact of photography which arrived in Shanghai at that time. Thematically, these paintings catered to very different tastes in his audience. Fishermen were a favourite subject of the scholar-gentleman because of the association with a carefree lifestyle. Zhong Kui, the demon-queller, is a deity in Chinese folklore and a subject appropriate for display during the Dragon Boat Festival. The subjects suited the literati taste and the popular pleasure respectively.

The technique used for rendering the rocks and the blossoms in the *White Cat and Hibiscus* is that of the *gongbi* (meticulous) manner, which the artist derives from the elder Rens. The depiction of the white cat, without any linear definition, mitigates the overall schematic effect. Such a juxtaposition of forms with and without outlines is a direct heritage of Ren Xun's style. Even the arrangement of motifs follows a formula commonly adopted by Ren Xun: contorted rocks at the bottom, elongated branches reaching across the scroll, and an animal perching on the angular rock – together they form a decorative screen, typical of Ren Xun's *gongbi* paintings. Despite the stylistic reference, Ren Yi transforms them into his own artistic

idioms. His outlines are less rigid, and the layered colour washes that fill the forms are suffused in a spontaneous way. On the whole, there is some departure from the rigidity of the linear and schematic style of the elder Rens.

Peach Blossoms and Birds and Album of Various Subjects are both dated 1886. They represent the evolution of Ren Yi's style after he had copied the works of Bada Shanren. According to the Haishang Molin, Ren Yi obtained an album of Bada's from which he learned the method of the brush. He must also have copied other of Bada's paintings in the private collection of Gao Yong. Several elements in these paintings show Ren's stylistic affinity to Bada: the ease and spontaneity in the handling of the brush, the bold application of wet ink, the cool stares of the birds and the ducks, the animated rock forms, as well as the overall vigour and intensity in painting. A point to emphasise is that the full development of Ren Yi's spontaneous style is also due to his assimilation of other sources including Ren Xun, Wang Li and Hu Yuan.

REN YI (1840-95) and
HU YUAN (1823-86)
Portrait of Gao Yong
c1877

Ren Yi painted the portrait. Hu Yuan added the background.

Hanging scroll, ink and colour on paper
130.9 x 48.5 cm
With 2 seals of the artists (1 of Ren Yi and 1 of Hu Yuan); inscription and 1 seal of Yang Borun (1837-1911); additional inscription and 2 seals of Wang Ti (1878-1960)

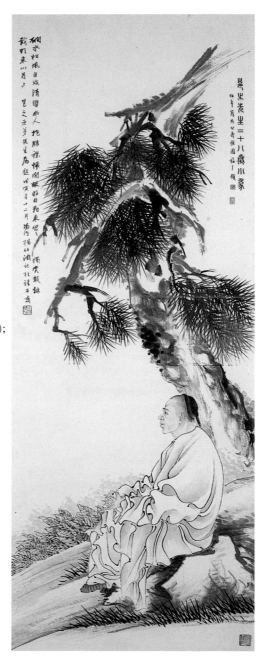

REN YI
1840-95

Fisherman
1881

Hanging scroll, ink and colour on paper
157.8 x 47.2 cm
With artist's inscription, signature, and
1 seal; 1 collector's seal
Gift of Sun Yufeng

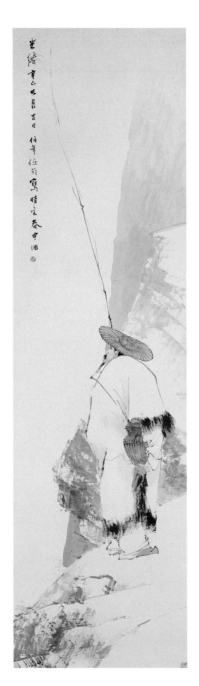

right
Zhong Kui
Not dated

Hanging scroll, ink and colour on paper
95 x 39.8 cm
With artist's 2 seals; inscription and 2
seals of Gao Yong (1850-1921)
Gift of Wei Tingrong

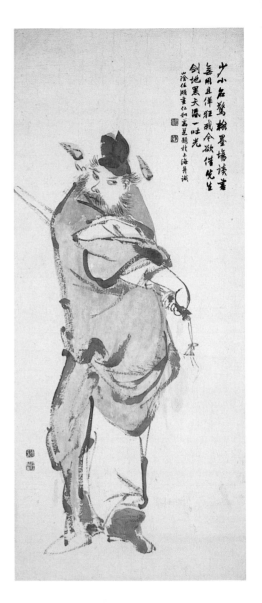

White Cat and Hibiscus
1882

Hanging scroll, ink and colour on paper
134.2 x 47.8 cm
With artist's inscription, signature, and
2 seals; 1 collector's seal

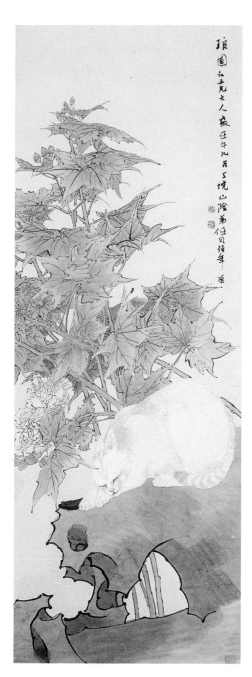

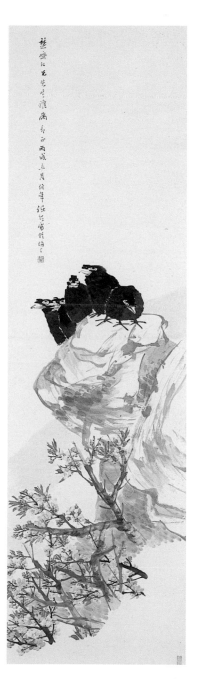

right
Peach Blossoms and Birds
1886

Hanging scroll, ink and colour on paper
174.3 x 47.7 cm
With artist's inscription, signature, and 1
seal; 1 collector's seal

REN YI
1840-95

Album of Various Subjects
1886

Album of sixteen leaves, ink and colour
on paper
Each leaf 23.9 x 34.6 cm
With artist's inscriptions, signatures, and
25 seals

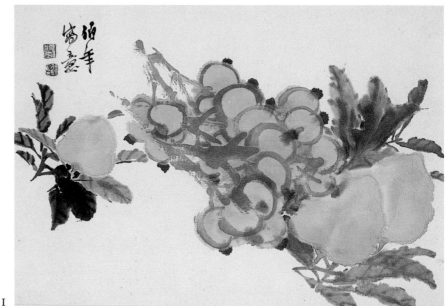

I

K

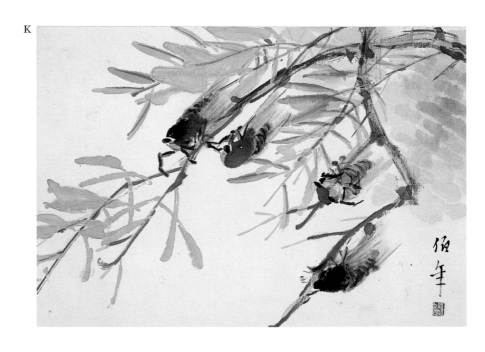

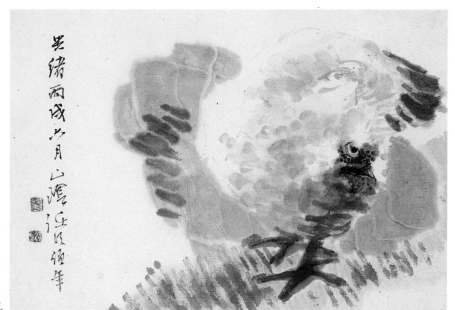

L

O

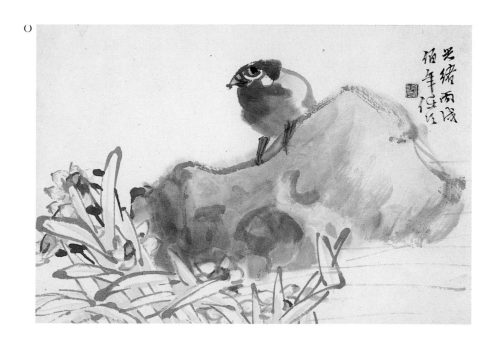

WU CHANGSHUO
1844-1927

Wu Changshuo was one of the major artists who introduced the *jinshi* approach to painting in the climate of antiquarianism in late Qing China. It is said that Wu began painting only late in life, and he often discussed the principles of painting with Ren Yi. Indeed, Wu first sought instruction in painting in his thirties, although his early interests were seal carving and calligraphy. His early training in these two art forms and his later acquaintance with collectors of ancient vessels – such as Wu Yun (1811-83), Pan Zuyin (1830-90) and Wu Dacheng – were instrumental in his development of a brush technique based on the ancient writings. He also had a special interest in stone-drum inscriptions. After seeing a few strokes of Wu's, Ren Yi believed that the novice painter would surpass him one day. He encouraged Wu to paint with his archaic calligraphic strokes. Wu's art reached maturity after the fall of the Qing empire, and his reputation rose rapidly. His works were greatly in demand by native and Japanese patrons.

Wu had travelled extensively before finally settling in Shanghai. He lived in Anji, Zhejiang province, after the dispersal of the family during the Taiping Rebellion. When the rebels reached his native village Zhangwu in 1860, they killed most of his family. Wu and his father wandered from region to region until they finally settled in Anji. Soon afterwards, Wu obtained his *xiucai* degree (the qualification for participating in the provincial examination in the civil service examination system) and assumed clerical duties. He had travelled to Hangzhou, Suzhou, Shanghai and Tianjin. During the Sino-Japanese War he followed Wu Dacheng's retinue to the frontier. In 1899 Wu served very briefly as a district magistrate in Andong (Lianshui), Jiangsu province. He settled in Shanghai around 1913, but during his early stays in the city he had befriended major masters of the day including Zhang Xiong, Hu Yuan and Ren Yi. Wu was an active member of various art associations in Shanghai, such as the Yu Garden Charitable Association of Calligraphy and Painting, and the Shanghai Tijin Association of Epigraphy and Painting.

Ink Lotus, dated 1896, reveals Wu's indebtedness to the earlier masters, Chen Shun, Xu Wei, Bada Shanren, Li Shan and to his contemporaries Ren Yi and Pu Hua in the pursuit of an expressive style. Yet his brushstrokes exhibit a strength which he strives to achieve by studying ancient writings (see the lotus stalks and the veins on leaves). His distinctly robust brushwork lends an aura of scholarly strength to his work, which is unmatched by Ren Yi and Pu Hua. He is concerned with the relationship of areas and the importance of voids.

Wu is certainly prompted by the design effects on pictorial surfaces, and this is clearly illustrated in the *Flowers*, a set of four hanging scrolls dated 1911. His combination of diverse subjects follows their natural associations. Yet the environments are barely suggested. Set against empty backgrounds, the subjects are, so to speak, suspended in voids. The paintings are a display of balance between solid and void, and of the vitality, movement and expression of brushwork. This evolved into a more vigorous style in Wu's later years. His art achieved full maturity in the early Republican period and is characterised by the tremendous force of the lines, sweeping movement of the brush, and a striking contrast of dark ink and glowing colours. The total effect is bold and dynamic.

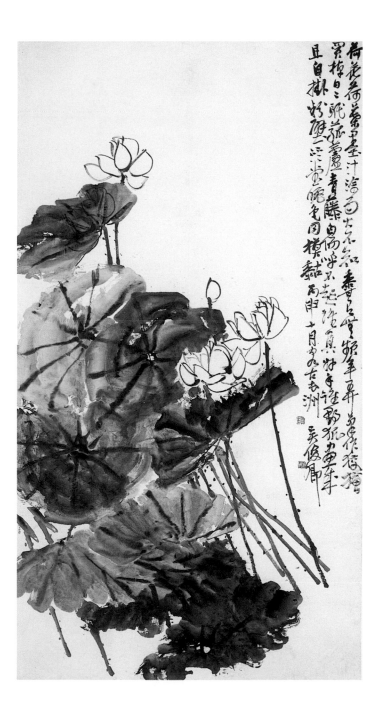

Ink Lotus
1896

Hanging scroll, ink on paper
179 x 96.1 cm
With artist's inscription, signature, and
2 seals

WU CHANGSHUO
1844–1927

Flowers

1911

Set of four hanging scrolls, ink and
colour on paper

Each scroll 250.7 x 62.4 cm

With artist's inscriptions, signatures, and
8 seals (2 on each scroll); 4 collectors'
seals

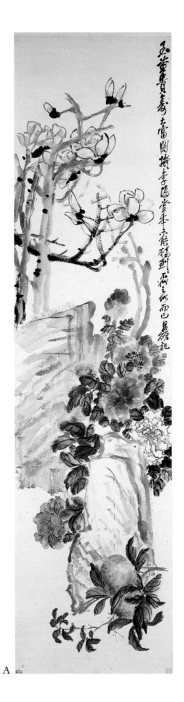

A

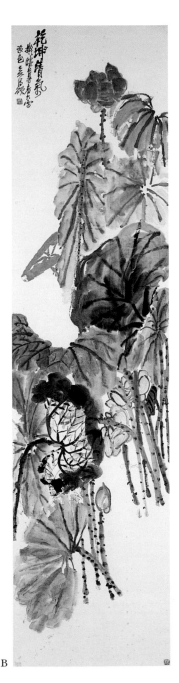

B

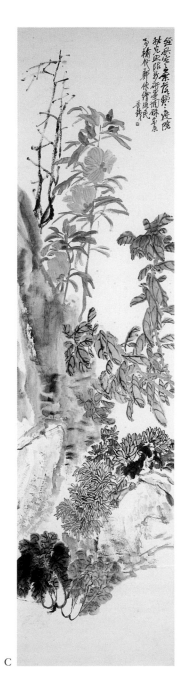

C

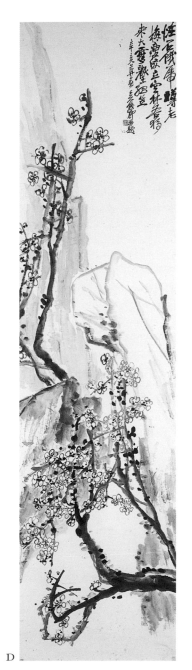

D

WU GUXIANG
1848-1903

Wu Guxiang was a native of Jiaxing who painted landscapes, figures and flowers. He moved to Suzhou and then to Yushan before finally settling in Shanghai. In 1892 he travelled to Beijing where he was offered opportunities to study ancient paintings in private collections, and after his return his reputation rose rapidly in Shanghai.

Wu was a follower of the Wu School in landscape painting, and his influences included Shen Zhou, Wen Zhengming and Tang Yin. Later he studied the works of Dai Xi and was able to draw upon the styles of both the Wu and the orthodox schools in developing a style of his own.

Carrying a Qin Zither amongst Pines and Streams exemplifies his Wu School inheritance. Although the inscription cites Tang Yin as the basis for the work, Wu does not seek formal likeness in his interpretation. Certain stylistic elements are no doubt derived from the Wu School, if not directly from Tang Yin. These include the fine, crisp brushwork, the sharp edges of the rocks, as well as the long vertical format of the painting. When the mountains are tinted with a yellowish-brown wash, they appear to be bathed in light. The richness of textural plays and the variety of colour values give the landscape elegance and solemnity.

In figure painting, Wu followed the style of Gai Qi in representing women of extraordinary delicacy. This is evident in the *Lady*, in which the figure is delicately drawn and coloured with light washes. By the side of a stream stands an ethereal lady whose vaguely suggested body echoes the gently curved tree trunk and the windswept willows. The disinterest in the substance of the physical body is a contrast to the concentration of texture strokes on the sculptural forms of the rocks along the shore.

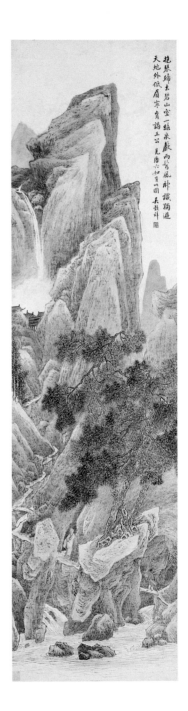

Carrying a Qin Zither amongst Pines and Streams
Not dated

Hanging scroll, ink and colour on paper
177 x 46.4 cm
With artist's inscription, signature, and
1 seal; 1 collector's seal
Gift of Qian Jingtang

Lady

Not dated

Hanging scroll, ink and colour on paper

97.5 x 46.4 cm

With artist's inscription, signature, and 2 seals; 2 collectors' seals

Gift of Qian Jingtang

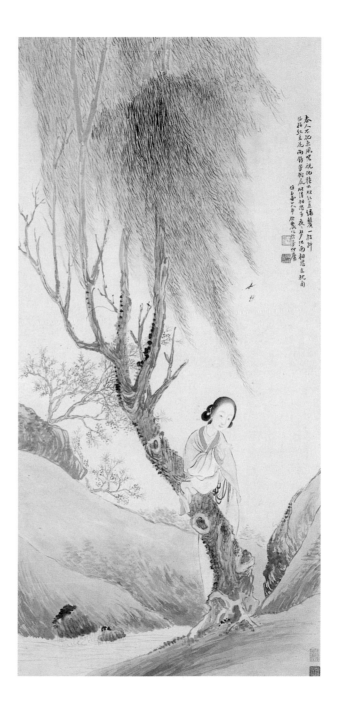

Wu Qingyun
d1916

Wu Qingyun, also known as Wu Shixian, was a landscape specialist from Nanjing. He travelled to Japan, and after his return he sold paintings in Shanghai. According to the *Haishang Molin*, his works were particularly favoured by Guangdong buyers.

Wu was especially good at painting misty mountains. Not only did he fill the air with a mist of dust and moisture, he also created strong contrasts of light and shade. Critics often comment on his assimilation of Western techniques into Chinese painting, but the misty effect and the darkened landscape also recall the works of Mi Fu and of Gong Xian in his hometown. Wu's eclectic use of native and foreign styles is exemplified by *Evening Glow on Mountains and Streams,* dated 1901. Despite the illusional effect, the depiction does not seem to be based on the study of light and optics as in Western atmospheric perspective. The colours change from cool to warm tones as distance increases, and are used mainly for suggesting the weather, time and mood, not for the articulation of perspective. The up-tilted ground plane and the spatial ambiguity of the landscape suggest that the borrowing of Western techniques is only partial and selective.

Evening Glow on Mountains and Streams
1901

Hanging scroll, ink and colour on paper
145.5 x 78.5 cm
With artist's inscription, signature, and 2 seals

GAO YONG
1850–1921

Gao Yong was both a patron and an artist in Shanghai. Since his twenties he had been supporting artists and was the patron-friend of Xugu, Ren Yi and Yang Borun. Later he was involved in the drafting of the charter for the Yu Garden Charitable Association of Calligraphy and Painting. He was himself a famous calligrapher.

Gao came from a scholar-official family of Renhe (present-day Hangzhou), Zhejiang. His father Gao Shusen had served in the office of Li Hongchang, assisting in the drafting of treaty provisions in relation to foreign trade. His younger brother Gao Yu was a *zhusheng* (Government Student) and later the Salt Commissioner of the Lianghuai region. As for Gao Yong, he had been appointed Prefect of the Jiangsu province, although service in the bureaucracy was not his aspiration. The political turmoil during the late Qing period was a trauma for Gao as for almost every scholar. After the Sino-Japanese War, he adopted the sobriquet of *longgong* (Mister Deaf), which probably suggests his wish to escape from further upsetting news. With the collapse of the Qing dynasty, he abandoned his official career and supported himself by selling calligraphy in Shanghai. He died in 1921 at the age of seventy-one.

Gao was devoted to calligraphy; both his father and younger brother were famous calligraphers. From an early age he had been immersed in studies of ancient calligraphy:

the works of the Qin, Han, Wei, Jin, Six Dynasties, Tang, Song and in particular the writings of Li Yong (678–747). It was said that he studied too hard and became ill, thus giving himself the sobriquet of *Keli* (Poor Li).

Gao painted occasionally, following the styles of Shitao and of Bada Shanren. The flowers and rocks in the *Ink Lotus* are in the manner of Bada, to whom Gao dedicates this painting. It is notable that Gao owned a collection of art, including the paintings of Bada. Certain stylistic differences between Bada's and his paintings can be detected. Whereas Bada tends to explore the fluctuations of brush pressure to give undulating lines for lotus stalks, Gao adopts a forceful style by preserving a firm pressure as the brush moves across the paper. Moreover, he does not work as fast as Bada, and this is evident in the rock depiction. Bada's swift use of inkwash texturing features nuance in tonal variation. Gao neatly applies strokes of varied tones one after the other. The overall stillness and solemnity of Gao's painting is completely his own.

Ink Lotus
1908
Hanging scroll, ink on paper
194.5 x 58.9 cm
With artist's inscriptions, signature, and 4 seals; 2 collectors' seals
Gift of Qian Jingtang

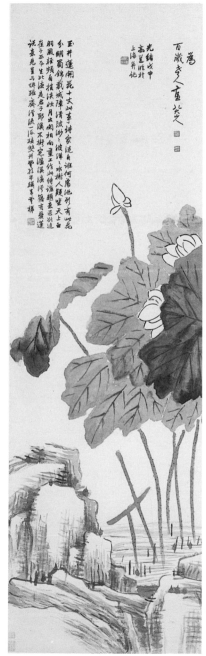

LU HUI
1851-1920

Lu Hui was a gifted artist who mastered a range of subjects and styles. He was connected to famous personages of the day, including scholar-officials and collectors. This gave him opportunities to study ancient works of art in private collections, which was instrumental in developing his style.

Lu was a native of Wujiang, Jiangsu province. In his youth, he travelled with Liu Deliu (1806-75) with whom he studied flower and bird paintings. Later he met Wu Dacheng who highly appreciated his works. This must have enabled him to gain access to Wu's rich collection of ancient bronzes, jades, seals, calligraphic work, and paintings, and it is not surprising that Lu, like Wu, was devoted to the study of epigraphy. Lu served as Wu's private secretary and followed Wu to the borders to fight against the Japanese. Despite the defeat, this journey introduced him to the gorgeous scenery of the frontier.

In 1896 Zhang Zhidong (1837-1909), then Acting Governor-General of Jiangsu, recruited famous artists to illustrate the *Chenghua Shilue*, a text written by Wang Yuanyun about princely education. Lu Hui was assigned the leadership of this painting project. His works enjoyed critical acclaim within the court, because his portrayals of costumes and vessels not only followed the ritual regulations of successive periods but evoked an antique refinement.

Lu Hui had also served as the connoisseur of calligraphy and painting for famous collectors like Pang Yuanji (1864-1949) and Sheng Xuanhuai (1849-1916). He had lived in Pang's mansion in Shanghai for a considerable period. He returned to Suzhou in his late years, but letters from those seeking his paintings came endlessly.

Lu Hui's direction in art was closely related to his wide exposure to ancient paintings. *Landscapes after Various Masters*, dated 1903, exemplify his practice of *fang* which emphasises creativity through imitation of ancient models. In his inscriptions, Lu Hui cites Wang Qia (d805), Guo Xi (c1000-c1090), Dong Yuan (d962), Mi Youren (1086-1165), Cai Zhibai (1272-1355), Wang Gongwang (1269-1354), Wang Meng (1308-85), Zhao Mengfu (1254-1322), Sheng Mou (c1300-c1360) and Ke Jiusi (1290-1343) as his sources of inspiration. Despite the diversity, Lu's brush idioms underscore his orthodox heritage, and the influence of Wang Yuanqi is readily noticeable.

The richness and refinement of Lu Hui's landscape are all represented in the *Clearing Clouds on the South Mountain*, dated 1911. Lu's direction in landscape painting is revealed in his inscription on this painting. He writes:

I once saw Fan Kuan's depiction of the North Mountain (Mount Heng in Hebei), and I am here imitating his rich and dense landscape to create this work, *Clearing Clouds on the South Mountain* (Mount Heng in Hunan). In my twenties I learned to paint landscapes; and in my thirties I sought to follow the paths of the Four Wangs, Yun, and Wu of the early Qing period. All these masters followed the traditions of the Song and Yuan and regenerated their own styles. They immersed in studying past paintings and managed to gain from them. If methods and rules turn out to be bounds, is it easy to treat them like transparent scales [which cover and protect a fish]? Mister Boyu gave me this piece of old paper and requested for my painting. But I have not painted despite a lapse of three years. Having seen the old painting [of Fan Kuan], I paint this work in imitation of his idea. My use of the brush and ink still follows past tracks. How can it be? It is just because I am learning the methods of the school.

The *Album of Various Subjects*, dated 1891, reveals Lu's mastery of a range of subjects and styles. Although his subjects (peacock, goldfish, deer, steed, white mice, pomegranates, bat, and so on) might find favour with a wider audience, Lu is able to adorn his paintings with

refinement and lyricism, avoiding too cloying a style. His source of influence is not only his teacher Liu Deliu, but also the orthodox master Yun Shouping. In several leaves, Lu juxtaposes contrasting styles in a single composition, giving unusual visual effects. In Leaf E, the leaves of the pomegranates are rendered in both the outlined and the boneless methods. In Leaf G, the meticulous depiction of the bat and the lotus is a contrast to the spontaneous rendering of the rock. The visual tensions resulting from the juxtaposition of contrasting styles offers great creative potential.

Clearing Clouds on the South Mountain
1911

Hanging scroll, ink and light colour on paper
153.3 x 69.3 cm
With artist's inscription, signature, and 2 seals

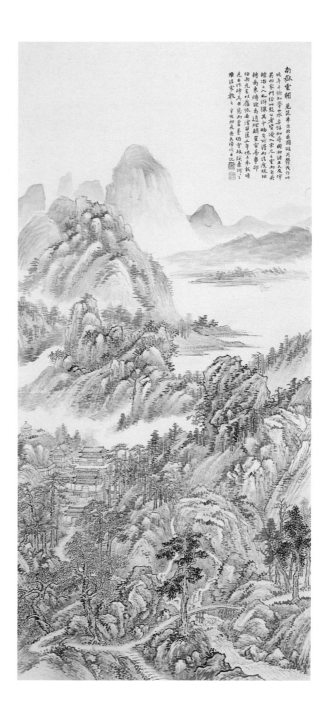

Lu Hui
1851–1920

Landscapes after Various Masters
1903

Album of ten leaves, ink and colour on paper

Each leaf 26.4 x 34.3 cm

With artist's inscriptions, signatures, and 15 seals; 1 collector's seal

A

F

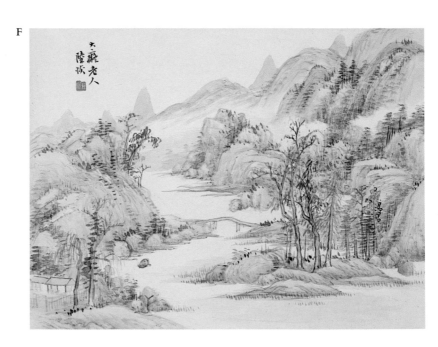

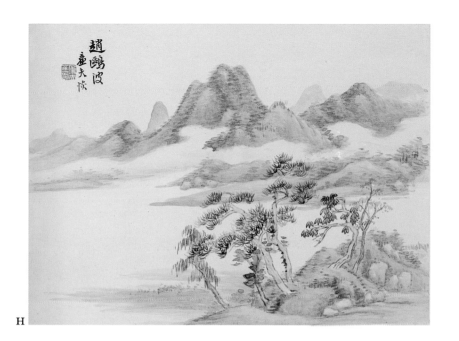

H

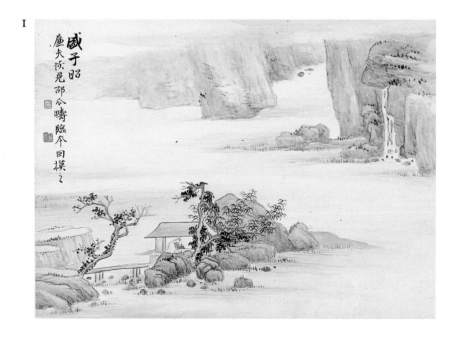

I

LU HUI
1851-1920

Album of Various Subjects
1891

Album of eight leaves, ink and colour on
silk
Each leaf 27 x 34.5 cm
With artist's inscriptions, signatures, and
8 seals (1 on each leaf)

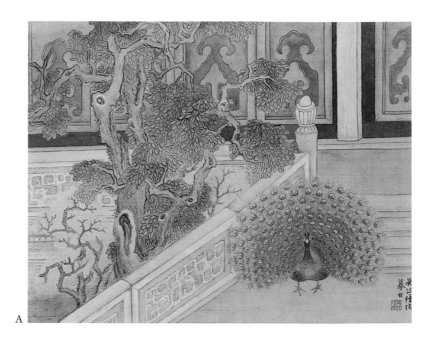

A

B

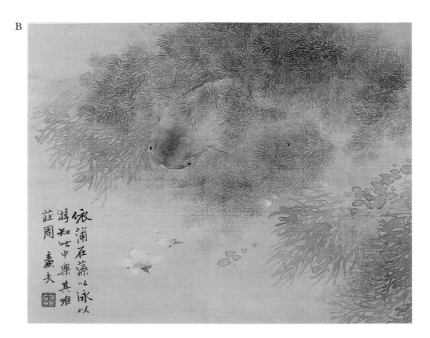

E

G

121

Ren Yu
1854-1901

Ren Yu was Ren Xiong's eldest son, but his father died in 1857 when he was only three years old. Other than following in the footsteps of his father, he pursued an artistic path of his own.

It is likely that Ren Yu received some kind of instruction from Ren Xun, and possibly from Ren Yi, as his works indicate his continuation of the trend set by the elder Rens. This is exemplified by the *Peacock, Rocks, and Banana Tree*, a work derived essentially from the pictorial languages of his seniors.

Ren Yu eventually moved away from the elder Rens and sought his own direction in art. Of all the subjects he depicted, his landscapes were the most impressive and were highly appreciated by critics of his time. The art critic Zhang Mingke praised them for being refined and untrammelled, whereas Yang Yi believed that the artist had opened up a new path in the genre. *Traveller in the Mountain* is painted after a Song version in 1891. A man on horseback is set against a simple background with two tall trees and a distant cliff. The precise drawing of the horse echoes the chiselled trees rendered by the delicate, angular brushwork. He uses a similar angular brush technique to portray the distant cliff that sharply cuts the surface in a diagonal manner. Such stylistic features recur in his late landscapes in the 1890s.

There were negative comments in the literature about Ren's lifestyle. Apparently, the artist was lazy, slack in work and indecorous in behaviour. He was also notorious for his slovenly appearance and his addiction to opium smoking. He died before his fifties, and thus his corpus of paintings was small.

Peacock, Rocks, and Banana Tree
Not dated

Hanging scroll, ink and colour on paper
150 x 39.7 cm
With artist's signature and 1 seal;
1 collector's seal

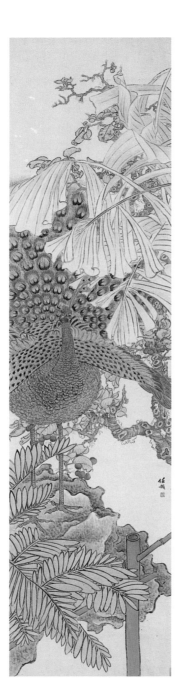

right
Traveller in the Mountain
1891

Hanging scroll, ink and colour on paper
119.9 x 46.1 cm
With artist's inscription, signature, and
seal; 2 collectors' seals
Gift of Wu Benyu

Ni Tian
1855-1919

As a native of Yangzhou, Ni Tian contributed to bringing the Yangzhou painting tradition to Shanghai. He followed Hua Yan and had studied painting with Wang Su (1794-1877). He was famous for his depictions of figures, ladies and archaic Buddhist deities. According to the *Haishang Molin*, Ni migrated to Shanghai during the mid-Guangxu era (1875-1908), and he stayed there for almost thirty years until his death. Apparently, the artist had also been active in Suzhou, as his name is included in the Suzhou gazetteer.

Despite his following Hua Yan's styles, he was drawn to the styles of Ren Yi while in Shanghai. Many of his paintings done in Shanghai reveal his stylistic affinity to Ren Yi, and in the album *Flowers and Insects*, dated 1908, he followed Ren in terms of subject matter, colour schemes and techniques. Several leaves in this album bear a resemblance to those in Ren Yi's *Album of Various Subjects* of 1886. Overall, this album shows the richness and vigour of Ni's paintings, as remarked by Yang Yi. Nevertheless, his works lack the compelling force to be found in the art of Ren Yi.

In the *Portrait of Wu Changshuo*, Ni adds the landscape setting and the robes to the portrait done by an anonymous artist. According to the inscription, this is the portrait of Wu Changshuo at sixty-six *sui*, and Ni's rendition must be done in or after 1909. The dragging, undulating lines (the draperies, the branches and the contours of the rocks) underscore his stylistic indebtedness to Hua Yan. Ni favoured a more vigorous and forceful style in his later years. The landscape in this painting shows a rugged effect that differs from his earlier mild, elegant landscapes. The rich contrast in ink tonalities produces a powerful visual effect.

Portrait of Wu Changshuo with background painted by Ni Tian
c1909

Hanging scroll, ink on paper
120 x 45.5 cm
With artist's inscription, signature, and 2 seals
Gift of Qian Jingtang

Flowers and Insects
1908

Album of twelve leaves, ink and colour
on paper
Each leaf 26.6 x 30.9 cm
With artist's inscriptions, signatures, and
12 seals (1 on each leaf)

C

G

H

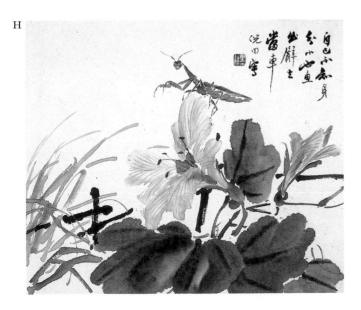

CHENG ZHANG
1869–1938

Cheng Zhang's ancestral home was in Xiuning, in Anhui province, but he moved to Taixing in Jiangsu and finally settled in Shanghai. The artist taught at the Qinghua University in Beijing, the Caoqiao Secondary School in Suzhou, and the China Public School in Shanghai.

In his early years, Cheng mastered the *gongbi* (meticulous) painting technique and followed the 'boneless' tradition (without linear definition) in floral depiction. In his later years he incorporated Western representational techniques into paintings, emphasising the effect of light on forms. He also used a range of hues to enhance the decorative quality of his works.

White Hawk represents his early *gongbi* style in flower and bird painting. A tamed white hawk, poised in profile, is perching on a contorted rock. The subject and the composition remind us of paintings produced within the court academy. Although graded tonalities of ink and colour are used to feature the texturing of the hawk and of the rock, tension arises from the incompatibility between the two-dimensional pattern of the bird and the sculptural form of the rock.

White Hawk
Not dated

Hanging scroll, ink and colour on silk
80.1 x 44 cm
With artist's signature, and 1 seal

FURTHER READING

BROWN, Claudia and JU-HSI CHOU. *Transcending Turmoil. Painting at the Close of China's Empire 1796-1911*. Phoenix, 1992.

CAHILL, James. 'The Shanghai School in Later Chinese Painting', in Mayching Kao, ed., *Twentieth-Century Chinese Painting*. Hong Kong, Oxford and New York, 1988.

CAHILL, James. *The Painter's Practice: How Artists Lived and Worked in Traditional China*. New York, 1994.

CHUNG, Anita. 'Xugu: The Paradoxical Identity of a Literatus and a Professional Artist', *Orientations*, 25 (April 1994), 47-54.

DING, Xiyuan. *Xugu Yanjiu*. Tianjin, 1987.

DING, Xiyuan. *Ren Bonian*. Shanghai, 1989.

GE, Yuanxun. *Huyou Zaji*. 2 vols. Taipei, 1968.

GOODMAN, Bryna. *Native Place, City, and Nation. Regional Networks and Identities in Shanghai, 1853-1937*. Berkeley, Los Angeles and London, 1995.

JOHNSON, Linda Cooke. *Shanghai: From Market Town to Treaty Port, 1074-1858*. Stanford, 1995.

SHANGHAI MUSEUM. *Masterworks of Shanghai School Painters from Shanghai Museum Collection*. Hong Kong, 1991.

VINOGRAD, Richard. *Boundaries of the Self. Chinese Portraits, 1600-1900*. Cambridge, 1992.

WAKEMAN, Federick Jr and WEN-HSIN YEH, eds. *Shanghai Sojourners*. Berkeley, 1992.

WANG, Ke. 'Qingmo Shanghai jinshi shuhuajia de jieshe huodong', *Duoyun*, no. 12 (January 1987), 142-8.

WANG, Tao. *Yingruan Zazhi*. Preface dated 1871. Reprint, Shanghai, 1989.

WEI, Betty Peh-Ti. *Shanghai: Crucible of Modern China*. Hong Kong, Oxford and New York, 1987.

YANG, Yi. *Haishang Molin*. Preface dated 1919. Reprint, Taipei, 1988.

ZHANG, Mingke. *Hansongge Tanyi Suolu*. Preface dated 1908. Reprint, Shanghai, 1988.

ZHOU JUNFU, ed. *Qingdai Zhuanji Congkan*. 205 vols. Taipei, 1985.